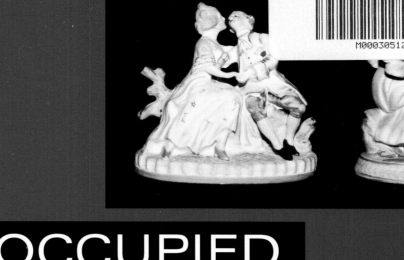

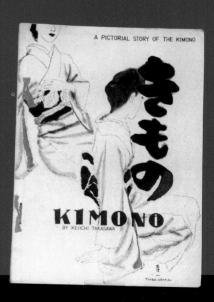

OCCUPIED
JAPAN

Florence Archambault

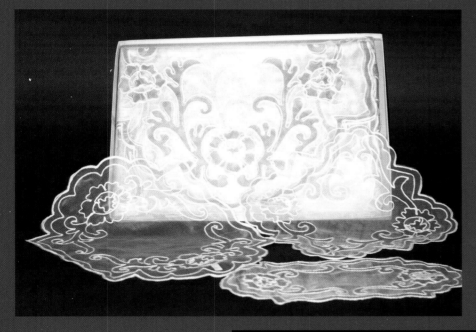

FOR THE HOME

Schiffer Publishing Ltd

4880 Lower Valley Road, Atglen, PA 19310 USA

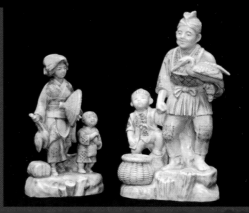

DEDICATION

To the late Frank Travis

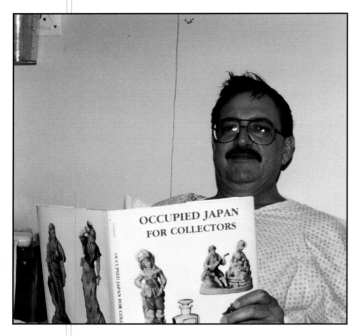

An Occupied Japan collector of the best sort, Frank left a legacy of dedicated devotion to the field. When Frank first learned that he had a brain tumor, he immediately began to photograph new marks and objects in his collection to share with the Occupied Japan Club members and with me. Frank was so devoted that during his hospital stay for surgery he continued to be an active O. J. collector. He sent me the picture of himself in bed reading my first book, along with the following letter:

The gist of the photo and words should be how relaxing a serious hobby can be. Here I am two or three days before brain surgery, having just been told the tumor is larger than previously expected. Making it not totally operable. I am reading your book (which I have memorized) as they tell me and take my blood pressure and pulse (both of which are normal). Shows where my priorities are. Now if a serious hobby does this under a high stress period, imagine all the good possibilities of a hobby after a normal stressful day. Interesting thought, right?

Frank is sorely missed by all the members of the Occupied Japan Club. His extraordinary attitude towards collecting is a model for all those who follow...both new and experienced collectors. Rest in peace, Frank.

Copyright © 2000 by Florence Archambault
Library of Congress Catalog Card Number: 00-100059

Cover Design by Bruce Waters
Book design by Blair Loughrey
Type set in Zurich/Korinna

ISBN: 0-7643-1133-6
Printed in China
1 2 3 4

Published by Schiffer Publishing Ltd.
4880 Lower Valley Road
Atglen, PA 19310
Phone: (610) 593-1777; Fax: (610) 593-2002
E-mail: Schifferbk@aol.com
Please visit our web site catalog at
WWW.SCHIFFERBOOKS.COM

We are always looking for people to write books on new and related subjects. If you have an idea for a book, please contact us at the above address.

This book may be purchased from the publisher.
Include $3.95 for shipping. Please try your bookstore first.
You may write for a free catalog.

In Europe, Schiffer books are distributed by
Bushwood Books
6 Marksbury Ave. Kew Gardens
Surrey TW9 4JF England
Phone: 44 (0)208-392-8585; Fax: 44 (0)208-392-9876
E-mail: Bushwd@aol.com
Free postage in the UK. Europe: air mail at cost.
Please try your bookstore first.

CONTENTS

ACKNOWLEDGMENTS

This book is not the product of one person's energy, but rather the work of several people. I gratefully acknowledge the members of The Occupied Japan Club who gave so generously of their time in photographing the highlights of their collections and allowing me access to these photos for this and future books. I was overwhelmed with pictures...so many that it became very difficult to decide which ones to use.

I am very grateful to Laurie Travis who gave me permission to use, in this and future books, Frank Travis's photographs of his collection. Many are found in this book. I especially thank also Bob and Dixie Agnew, Roger and Kay Aycock, Chris and Jim Baker, Margaret Bolbat, Sigrid Bomba, Jeanne Cramer, Ray Crum, Nina Danielsen, Alvin Ferdinand, Kathy Gardner, Beverly J. Hearn, Charlene Knighton, Jessie Lange, Paul and Melissa Lushinsky, Jim and Dolly Michalek, Charlene Miller, Ruth Ann Rivers, Stephanie Sequin, Louis Smith, Ron and Linda Straight, Arlene Svenson, and Wayne Walters.

Further thanks go to Margaret Bolbat for her many photos of the newly found marks, and to her and Kathy Gardner for their unequivocal support. But most of all, thank you to my husband of nearly fifty years, Tom, who is always there to encourage me and to pick up the pieces.

INTRODUCTION

Collectibles are created for many good reasons, among them are rarity, workmanship, and sentiment. Objects marked "Made in Occupied Japan" are unique in the collecting world because they were set apart from all other products by a United States government memorandum declaring that objects exported to America following World War II and during the occupation of Japan by American troops, must be marked as being made in Occupied Japan. The order to use this mark was in effect from February of 1947 until the end of the occupation in April of 1952.

One of the first orders of business following the signing of the peace treaty in 1945 was to bolster Japan's economy. This was done by utilizing the factories that had survived bombings in Japan. From 1945 to 1947, only raw materials were exported from Japan. Therefore, Occupied Japan items all were made during a period of only five years. These collectibles are easy to date and identify with confidence. Contrary to the belief of some, there are no "unmarked" Occupied Japan items. In order to deem them part of the Occupied Japan (OJ) collectibles field, items or some part of the sets must originally have been marked "Made in Occupied Japan."

Prior to World War II, Japanese businesses manufactured a wide variety of ceramic items. Therefore, it was natural for ceramic items to be the largest group of Occupied Japan collectibles. However, articles in other categories, including sewing machines, tools, fishing equipment, numerous dinnerware sets...you name it, also were exported to the United States.

Usually, when one hears the words "Made in Japan" or "Made in Occupied Japan," the many dime store knickknacks that flooded the market in the 1950s come to mind. In fact, Japanese manufacturers also exported many extraordinary porcelain and bisque items that were designed to be sold in upscale gift shops,

including those on Fifth Avenue in New York. These are the pieces that seasoned collectors strive to add to their collections today. Many of the finer pieces are illustrated in this book, along with the more unusual items. Since most glassware, including stemware, was marked originally with paper labels, there is not an abundance of glass available today to Occupied Japan collectors.

VALUES

Placing values on collectibles is an arduous and risky task because there are so many variables to take into consideration. For the past several years I have been reviewing auction results, buy and sell ads, and the general market. I have also consulted with the owners of some of the pieces in this book. We cannot ignore either some of the prices obtained in the Internet auctions...some of which I find to be unrealistic. I have tried to be fair. These values are not written in stone. You may find items for less or more. The prices quoted in this book are only intended to be a guide. In the final analysis, it all depends on the strength of your want and your pocketbook. As Publilius Syrus said ca. 50 BC, "A thing is worth whatever the buyer will pay for it."

CLUBS

I cannot emphasize enough the value of belonging to a club that specializes in whatever your collecting area may be. The value of having a forum for the exchange of information is immeasurable. Newsletters are a great way to obtain valuable knowledge in your field. If the club has conventions, the camaraderie and friendships that result are priceless. If you are interested in information to become a member of The OJ Club, send a SASE to: The O.J. Club c/o Florence Archambault, 29 Freeborn Street, Newport, RI 02840-1821.

CERAMICS

PORCELAIN GROUPS

Porcelain figures are the most commonly found of the Occupied Japan pieces. Porcelain is highly glazed and usually painted in bright colors. The pieces that are marked "hand painted" generally are the nicer pieces. Much of the output of the Japanese potters were the figures dressed in what collectors call "colonial costumes." Many are also reminiscent of seventeenth century French dress. The collector is always looking for the multi-figured groups, and the seven-figure group shown is a prize, indeed.

Statues mounted on metal bases were sometimes designated as lamp bases or, as in the case of the one pictured, as a music box. Quite often the figures were never assembled as lamps or, if they were, their owners have removed the figures to use them alone as decorative items.

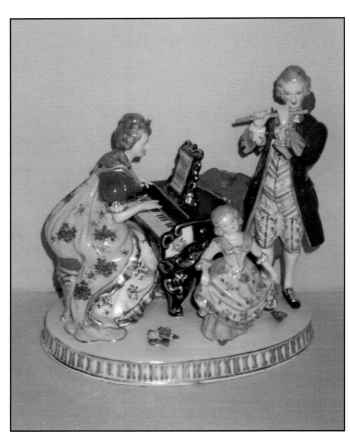

Above: A fetching little girl in a pink dress dances to music made by (we assume) her mother and father in this charming portrayal of a family scene, 9"W x 9"H x 5.5"D. Marked similar to #38 (a capital K in a wreath). *Walters Collection.* $175-200.

Right: This figurine receives the prize for the most figures on one base. There are seven. They include three women, a baby with a swan in its lap, a deer between the two standing women, and another bird hidden behind the woman on the right. Black MIOJ. It measures 7.75"H x 5.5"W. *Lange Collection.* $100-125.

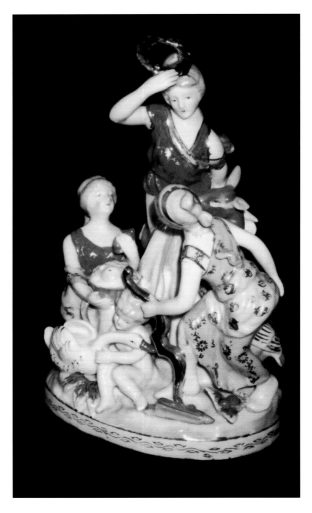

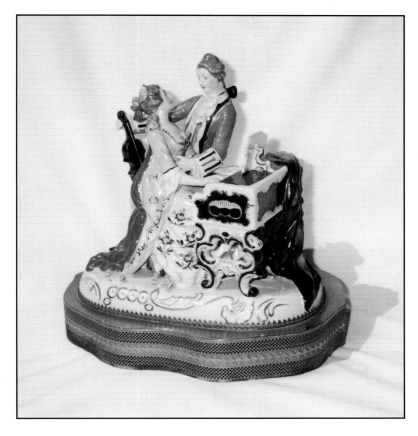

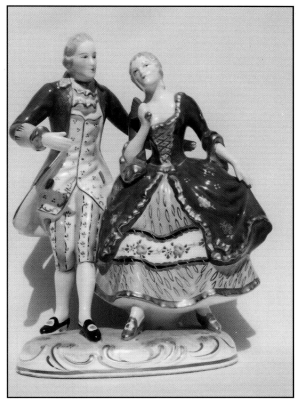

A typical rendering of the popular Colonial figures that populate the world of Occupied Japan, measuring 8.75"H with mark #81 (S.G.K.). *Gardner Collection.* $65-75.

Above: This lovely piece mounted on a brass base is believed to have held a music box. Its owner has replaced it. The man and woman are gazing longingly into each other eyes. The piece measures 9.5"W including the base. G*ardner Collection.* $100-125.

Right: Another lovely porcelain figurine mounted on a metal base. Sometimes these pieces were made into lamps. This gentleman appears to be proposing to his lady on bended knee while Cupid encourages her to accept. 8"L x 7"H x 5"D. Marked MARULACA MIOJ. An identical piece has been found in bisque with the Andrea mark #4. *Walters Collection.* $150-175.

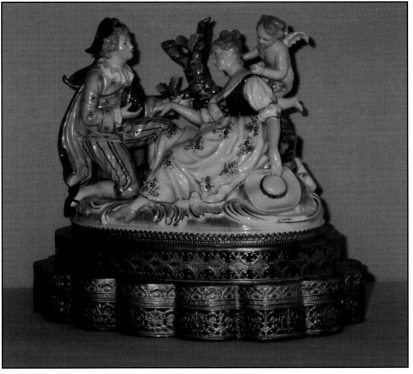

PORCELAIN PAIRS

The easiest way to determine whether or not a pair is matching is to compare their bases. In almost all instances, bases of pairs will be the same. It is not advisable to buy one figure of a pair hoping, someday, to match it up with its mate, although that has been known to happen. This is a decision you will have to make on your own.

The first pair, at 16 inches high, is one of the tallest pairs that has been found. Most collectors consider themselves fortunate if they can find figurines that measure 10 inches high and more. Some pairs are termed "mirrored pairs" when they are cast in opposite poses. Other pairs, such as the Spanish dancers, are similar in design and have matching bases.

The stunning pair of ladies with greyhounds is exquisitely painted and formed. Note the separation of the fingers. They were originally on lamp bases and the owner removed them for use as figurines.

The two that have dissimilar bases are correctly considered a pair since the coloring of the fabric in her skirt matches the fabric in his vest.

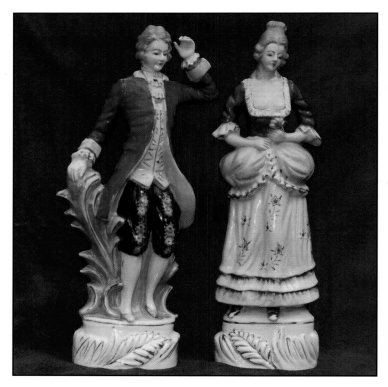

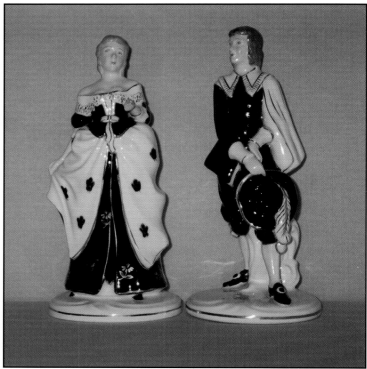

Left: This large Colonial pair is truly spectacular standing at 16"H. We can be assured that they are a matched pair since their bases are identical. They are marked with a red MIOJ. *Miller Collection.* $75-100.

Right: A cavalier and his lady done in cobalt blue and white with gold accents. Figures done in these colors are highly sought by collectors. Mark #181 (S.G.K.) *Walters Collection.* $100-125.

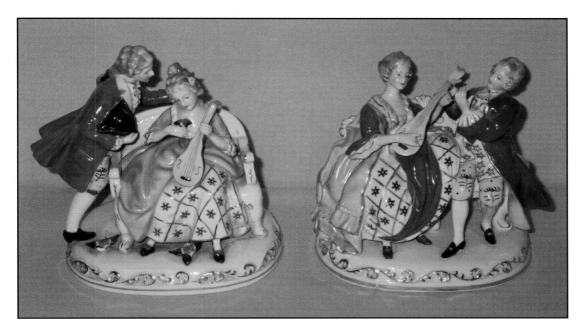

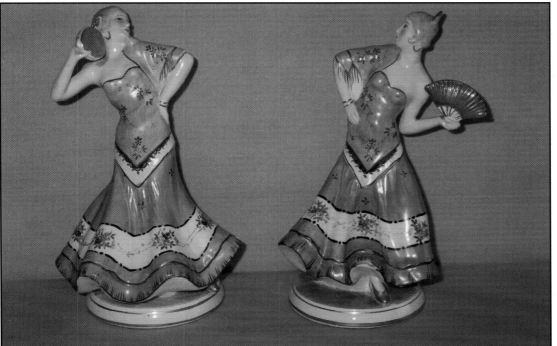

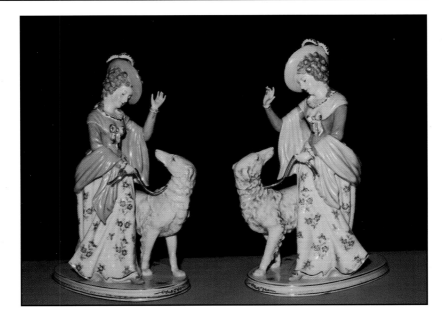

Top: A pair of courting couples. The men wear the same suits while their companions' dresses differ. Each is 6"W x 6"H x 5"D and are marked with a red MIOJ. *Walters Collection.* $65-75 each.

Center: A stunning pair of Spanish dancers strut their stuff. One shakes a castinet while the other uses her fan in the dance. They have a matte finish and are 9"H. Mark #81 (S.G.K.) *Walters Collection.* $100-125.

Bottom: A wonderful mirrored pair of ladies with their greyhounds. Even the coloring on these figures is reversed. This pair was originally on brass lamp bases from which they were removed. They stand 11.5"H x 7.5"L x 5"W and are marked with a blue ST (mark #181). *Travis Collection.* $450-500.

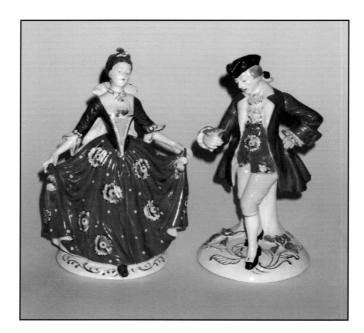

Top: Dressed for a ball this lady curtsies to her partner. Although the bases differ his vest matches the fabric in the skirt of her gown. 7.75" H with mark #181. *Bolbat Collection.* $100-125.

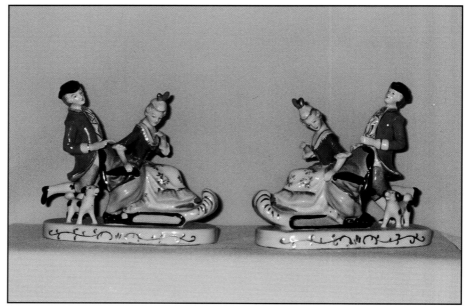

Center: A pair of sleighs with the gentleman pushing his lady. Their dog looks on. They sit on a 6" wide base and measure 5.5" to the top of the man's hat. Marked with a black MIOJ. *Author's Collection.* $150-175 the pair.

Bottom: This perky pair of cooks in their bright attire seem to be enjoying life. Measuring 6" high, they are marked with a black MIOJ. *Gardner Collection.* $45-50 the pair.

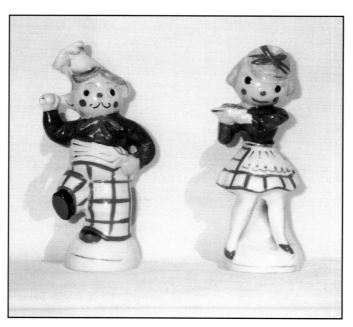

PORCELAIN LIKENESSES

This group contains pieces some of which are likenesses of European molds. The Florence replica is quite realistic, as is the Wedgwood likeness. None of the European pottery companies was exempt from having their products reproduced in Japan at this period and, in many cases, until you turn the piece over to read its maker's mark, you can be fooled into thinking the piece is authentic European.

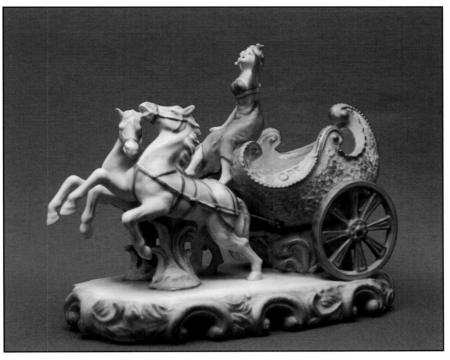

Although this figure appears to be bisque it is a glazed porcelain. It has a pearlized finish inside. Another faithful Dresden copy it is spectacular, not only in the workmanship, but also in its size. It measures 10"H x 13"L. Mark #4 (Andrea) *Ferdinand Collection.* $350-400.

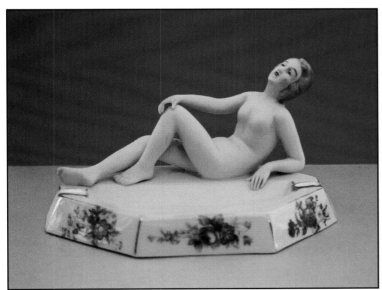

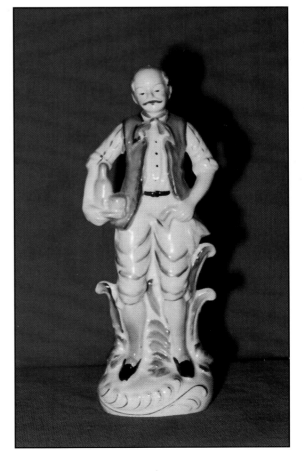

Above: The owner of this piece calls it his "nekkid" lady and considers it the best piece in his collection. The lady is bisque attached to a porcelain ashtray. Marked Shofu China similar to mark #85. 3.75"H x 6.75"W x 4.5"D. *Smith Collection.* $75-80.

Right: This very tall bartender (10.5"H) is holding a towel in one hand and a tray in the other. He sports a wonderful handlebar mustache. *Agnew Collection.* $75-100.

A faithful reproduction of the highly collectible Florence figurines this young lady is marked with mark #52 Maruyama and is 8.5"H on a 3"W base. *Walters Collection.* $40-45.

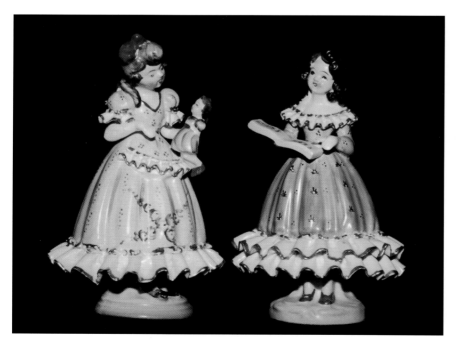

A pair of girls with ruffled skirts. One is holding a doll while the other a book. Marked with a simple MIOJ, they stand 7"H. *Lange Collection.* $30-35 each.

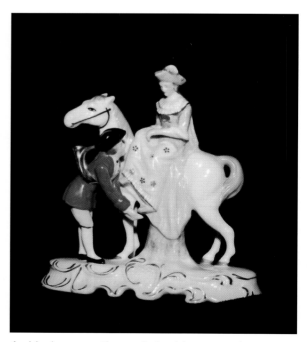

A chivalrous gentleman helps his companion dismount from her horse. 5.25"H. Marked Maruyama MIOJ. *Lange Collection.* $45-50.

Usually the execution of the Wedgwood copies leave a lot to be desired but this piece is a fine example of the Japanese ingenuity in copying other potters. The cigarette box is exceptionally tasteful and true to the Wedgwood tradition. It measures 2.5"H x 5.5"W x 4"D. Black MIOJ. *Travis Collection.* $15-20.

Bridge sets of ashtrays were very popular when both Bridge and smoking were in favor. This set shaped as the four suits of playing cards is very colorful with its pink roses. Each ashtray is approximately 3"W x 4"L. and has the Lenwile China Ardalt (mark #8). *Travis Collection.* $30-35 the set.

A typical Capo-Di-Monte replica covered bowl is decorated with the cupids so common to this type of porcelain. It measures 6"H to the top of the boy finial and is 6.5"W. Marked Hand Painted Occupied Japan in red script. *Rivers Collection.* $40-45.

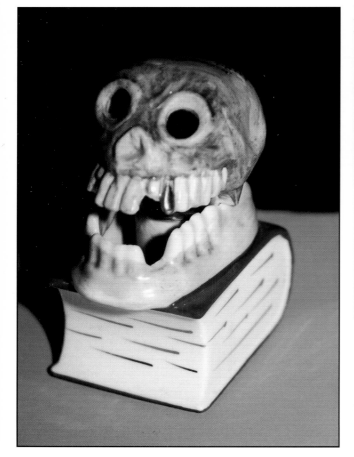

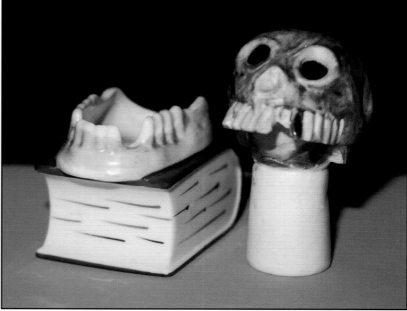

Left: This rather bizarre two-piece skull ashtray is also a nodder. It is a souvenir item with a Niagara Falls Canada decal on the top of the skull. 3.5"H x 2.5"W x 2"D. Both pieces are marked with a red MIOJ. *Travis Collection.* $20-25.

Above: The two pieces of the skull ashtray showing the lower teeth sitting on a book.

PORCELAIN LACE FIGURES

These wonderful Occupied Japan figures are adorned with porcelain lace which was the trademark of European Dresden-made pieces. They are even more wonderful since their lace is intact. The Japanese makers apparently had a problem perfecting the lace process, and many pieces today are found with their lace trim greatly damaged or disintegrating.

The ballerinas quite often appear to be dancing rather awkwardly in poses that defy gravity.

Those in their original shipping boxes show ingenuity in their packing. Pieces with their original boxes generally command a little higher price; you can add $10 to $15 to the cost of each.

The Japanese makers of porcelain lace figures did not limit their output to ballerinas, which are so characteristic of the Dresden potters, but applied this treatment to many other styles as well. "The Lacey Family" is a good example, as are several of the other figurines shown.

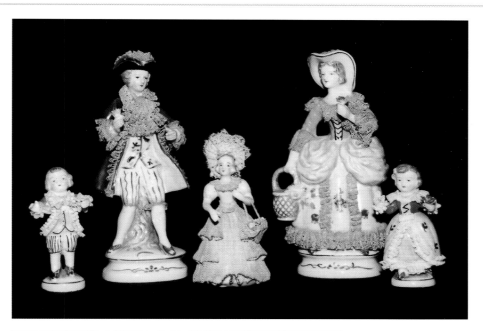

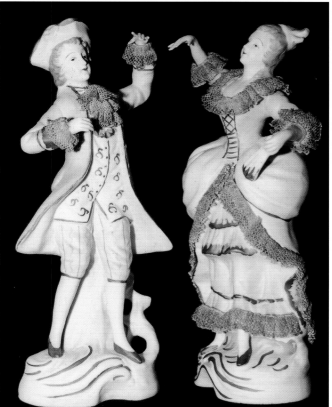

Above: Here we have "The Lacey Family" with the mother and father, teenager, and a little boy and girl trimmed with porcelain lace. (1) The little boy with arms in front has lace cuffs and trim on his jacket, 4"H, MIOJ, $25-30;
(2) The father wears a lace jabot and lace trim on his hat and cuffs, 7.5"H, MIOJ, $40-50;
(3) The teenager has a lace purse over her arm and a lace trimmed skirt, 5"H, marked #43 MIOJ, $30-35;
(4) The mother in this family has a lace collar and sleeves, 7.5"H, MIOJ, $40-50;
The little girl sports lace trimmed sleeves and skirt, 4"H, MIOJ. *Lange Collection.* $25-30

Left: Dancing bisque Colonial couple with lace trim and gold highlights. 10"H. MIOJ. *Lange Collection.* $75-100 the pair.

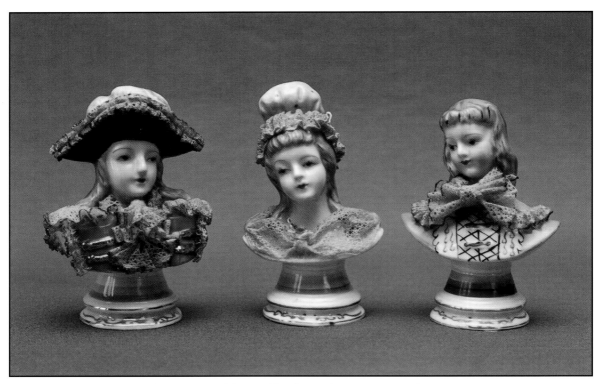

A trio of lace adorned busts. The first pair are mates and represent the aristocracy while the third with a scarf around her neck looks a bit more ordinary. 4.75"H. Red MIOJ. *Ferdinand Collection.* $45-50 each.

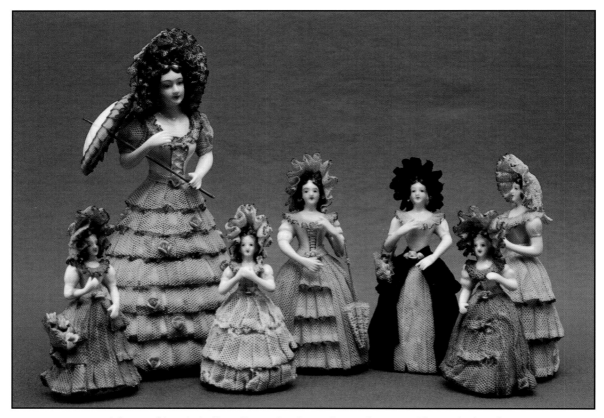

A bevy of lovely ladies all wearing lace trimmed gowns. The majority of them are carrying lace parasols. All marked MIOJ. *Ferdinand Collection.* 5"H $30-40, 6"H $40-50, 9.5"H lady with the open parasol $65-75.

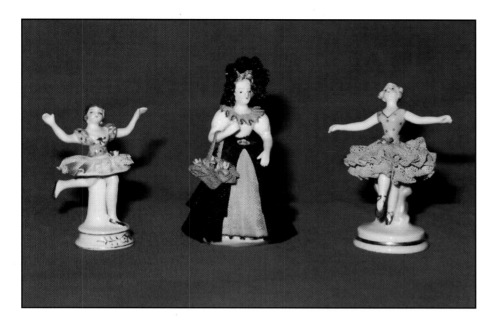

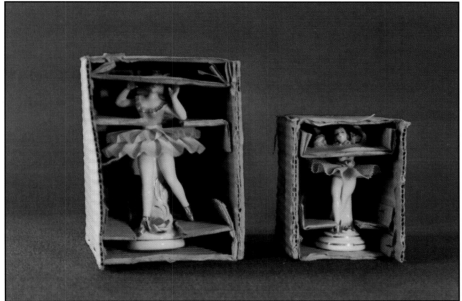

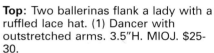

Top: Two ballerinas flank a lady with a ruffled lace hat. (1) Dancer with outstretched arms. 3.5"H. MIOJ. $25-30.
(2) Lady in black and tan dress carrying a basket. 5"H. MIOJ. $30-40.
(3) Another ballerina with gold ballet slippers stands on one toe. 5.5"H. Marked "KOUWA". *Agnew Collection.* $30-40.

Center: Two ballerinas in awkward poses reside in their original packaging. The small 4"H one is only marked with a label on the box. The larger 5.5"H dancer is marked CHIKUSA. *Ferdinand Collection.* $35-40 and $40-50.

Bottom: Four would-be stars of the ballet in pretty much the same pose. All 6"H. Black MIOJ. *Ferdinand Collection.* . $45-50 each.

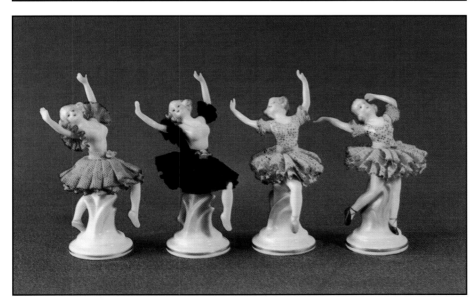

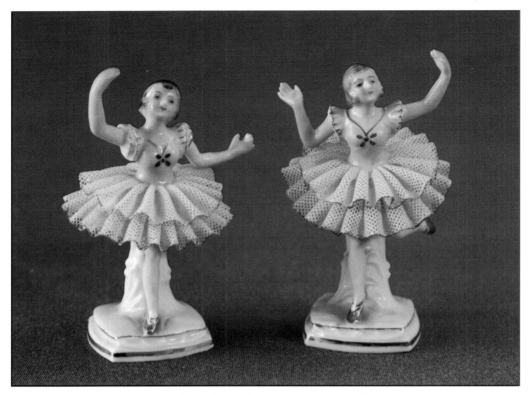

A pair of nicely done dancers pose with
their arms in the air. 4.5"H. Red MIOJ.
Ferdinand Collection. $35-40.

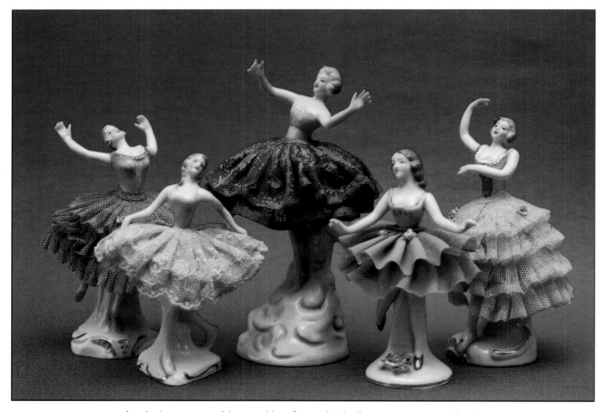

A whole troupe with net skirts from the ballet company ranging in
size from 5.5"H to 7.5"H put on a performance. All except No. 4
are marked with mark #77 Rosetti Chicago. *Ferdinand Collection.*
$30-60 depending on size.

HOKUTOSHA

Occupied Japan items that have the Hokutosha back stamp (#32) are of exceptional quality. Most are imitations of the beautiful Imari porcelain ware that Japan is so famous for. Hokutosha ware is not, however, limited to Imari styles; black, white, and gold pieces are further examples of the fine workmanship that is indicative of the Hokutosha mark. Hokutosha also produced a fine selection of figurines that copy Royal Doulton animals and children figures.

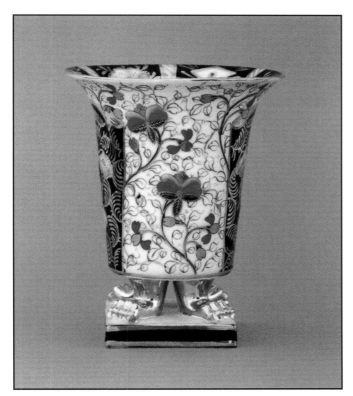

Left: This Imari-like Hokutosha urn on gold feet stands 8"H. It measures 6.25" across the top and is mounted on a 3.75" square base. Mark #32 Hokutosha. *Bolbat Collection.* $70-75.

Below: Three pieces representative of this pottery. All mark #32.
(1) Small round pin tray, 3.875" square, $12-15;
(2) A 6.5" diameter fluted plate, $25-35;
(3) A rectangular 4.375" x 2.875" pin tray. *Bolbat Collection.* $8.50-10.

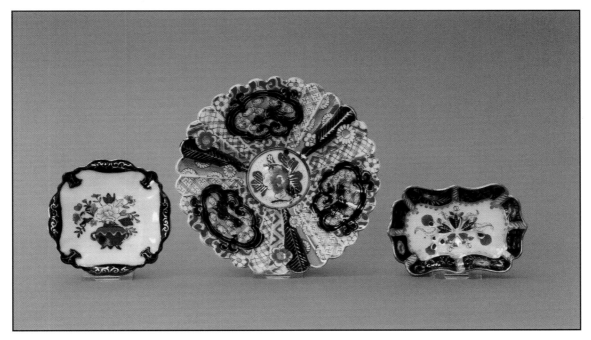

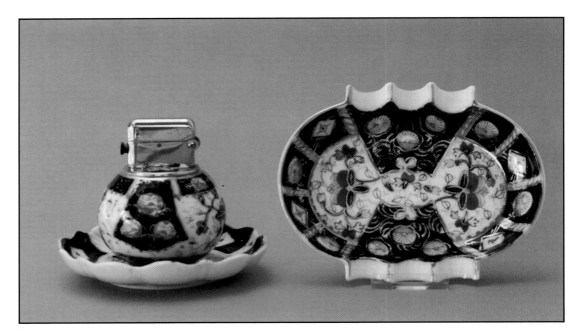

Top: A lighter with a tray and an ashtray done in the familiar colors of red, blue, and white with gold accents so traditional to Imari-ware.
(1) The lighter is 3.25"H and the tray measures 4.5". $30-35;
(2) The ashtray is 5.5'"x 4.5". *Bolbat Collection.* $12-15.

Center: More fine examples of Hokutosha are found in this handled basket and cup and saucer.
(1) This basket measures 4"H x 6"W x 3.75" deep. $55-65;
(2) The saucer to this set is 5.375" in diameter and the cup is 2.375" tall x 2.875" in diameter. *Bolbat Collection.* $25-28.

Bottom: Miniature Hokutosha pieces. (1) Mini watering can, 2.875"H x 3.625"W, $18-25;
(2) A small pin tray measuring 2.25" x 3.25", $8.50;
(3) A small platter is 4.25" x 5.25", $12-15;
(4) A child-sized casserole is 2.5"H x 4"W x 2.5" deep. *Bolbat Collection.* $35-40.

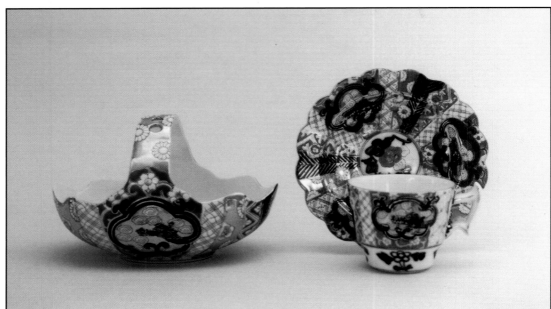

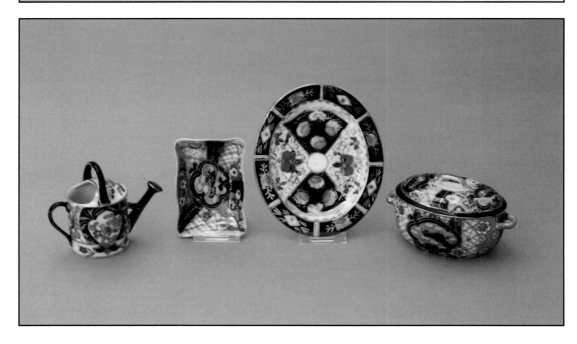

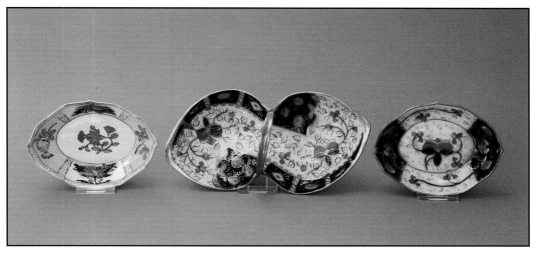

Two oval shaped dishes, 5" x 3.875" x 1" deep, $18-20 each. Handled dish measuring 8.25"W x 4" deep x 2.375" to the top of the handle. *Bolbat Collection.* $25-30.

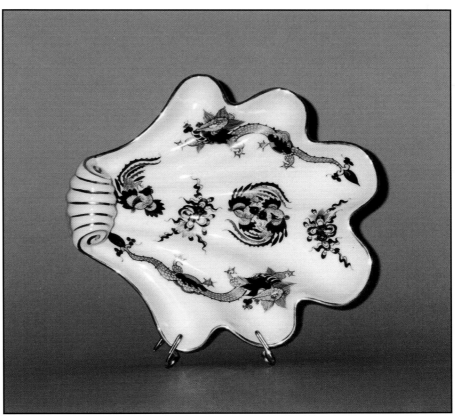

A black, white, and gold shell with the birds and dragons design. 9.5"W x 8.75" deep. *Bolbat Collection.* $45-50.

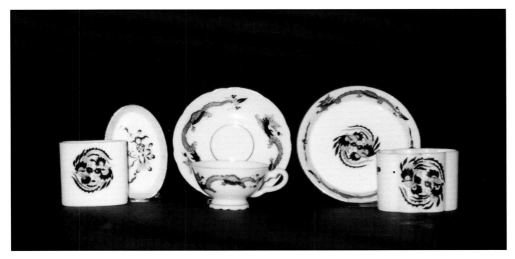

More white Hokutosha ware with the bird and dragon pattern. (1) Pin tray and holder, tray is 3.75" x 2.375" and the holder is 2.5" x 2.5", $30-35;
(2) Cup and saucer. The saucer is 4.5" in diameter and the cup stands 1.75"H, $15-18;
(3) A 4.75" diameter round tray, $12-15;
(4) Rippled holder, 2.25"H x 3"L. *Bolbat Collection.* $15-18.

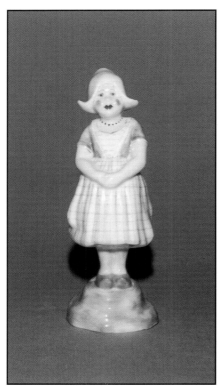

A 5.25"H bone china Dutch girl figurine. Mark #32 with Bone China in red above and HOLLAND in black below the mark. *Bolbat Collection.* $35-40.

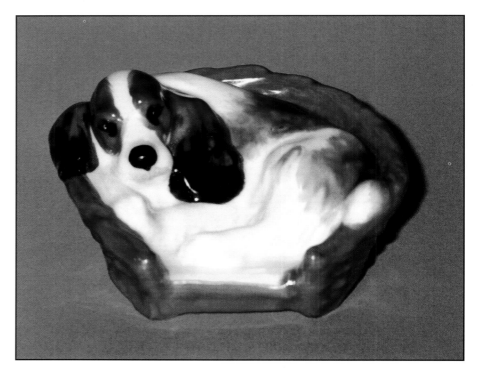

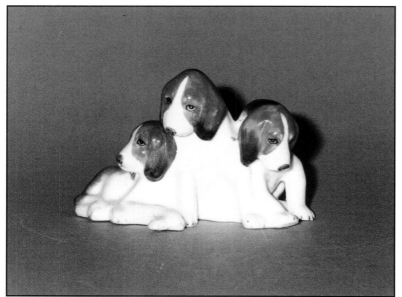

Above: A spaniel curled up in his bed. 3.5" x 3.5". This is a copy of a Royal Doulton figurine. *Bolbat Collection.* $35-40.

Left: A litter of three puppies cuddling together on a single base. 2.25"H x 3.25"W x 2.25" deep. *Bolbat Collection.* $30-35.

CERAMIC SETS

A great challenge among Occupied Japan collectors today is to find and complete the many ceramic sets that were exported to the United States. These sets are comprised of a variety of figures ranging from angels and cherubs to ladybugs and animals. Collectors who specialize in each of these subject areas, other than Occupied Japan collectors, also seek these little statues, so there is plenty of competition for them.

Moriyama clowns are further examples of fine work that is marked with the pottery name in addition to the magic words "Made in Occupied Japan." They were made in various sizes. According to authors Ralph and Terry Kovel, in their *New Dictionary of Marks,* the Noritake company used the Moriyama back stamp (#62) during the occupation era.

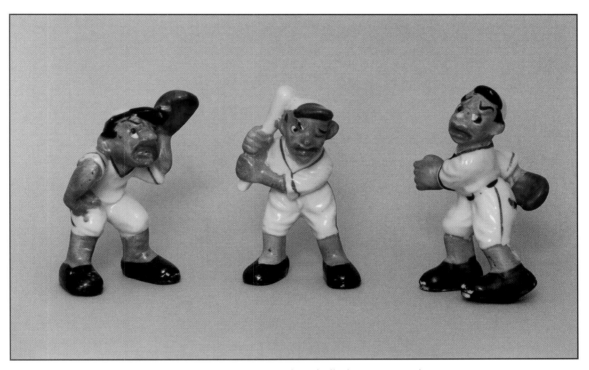

These three rather grotesque baseball players, a catcher, pitcher, and batter stand 3" to 4" high. They are marked with a black stamp on their feet.. *Lushinsky Collection.* $15-20 each

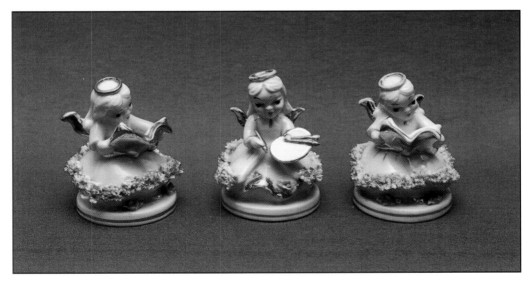

Two of these three angels are reading books while the third prepares to paint a picture. Mark #132. Black MIOJ. 4"H. *Ferdinand Collection.* $20-25 each.

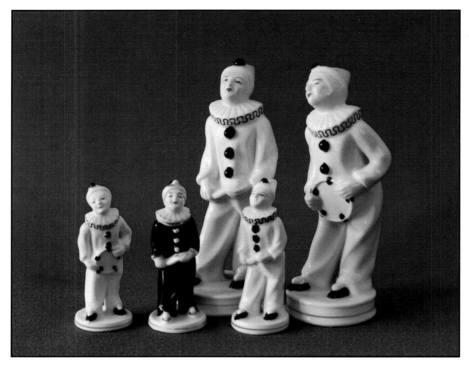

These exquisitely and meticulously fashioned clowns with a
highly polished glaze have mark #62 and are indicative of the fine
quality of the Moriyama mark. *Ferdinand Collection.* 7" H. $40-50
 4" H. $25-30.

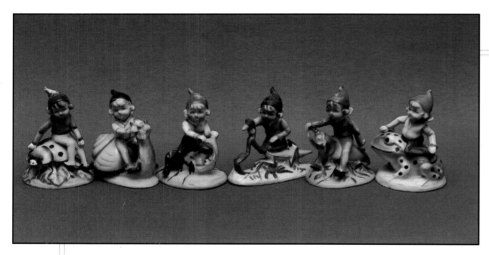

A set of six elves sitting on
insects except for the last
one who is perched on a
frog. Black MIOJ. 5"H.
Ferdinand Collection. $20-25
each.

A band of pixie musicians
with mark #106 MIOJ
except for the accordion
player who is marked
Made in Japan.. They
range between 2.5" and 3"
high. *Ferdinand Collection.*
$15-20 each.

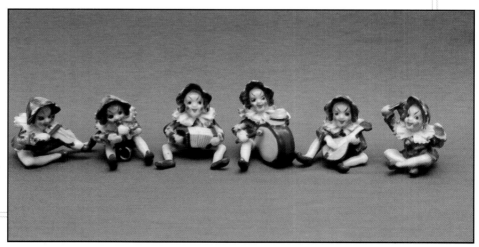

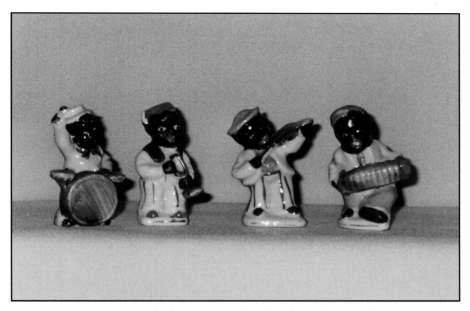

These four black musicians play the drum, horn, violin, and concertina. Black MIOJ. They are 2.75" H. *Author's Collection.* $15-20 each.

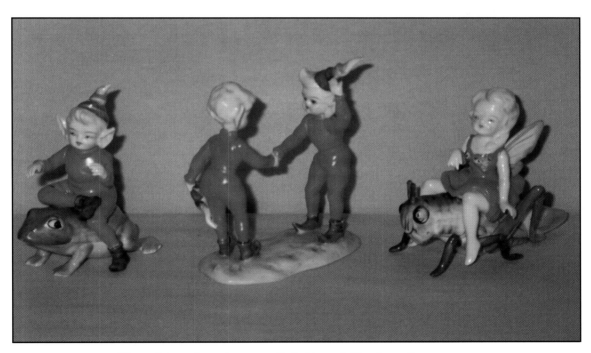

These interesting elves are all clad in red. One boy sits upon a frog while the girl is perched atop a grasshopper. They have mark #9 Ardalt. The pair in the middle shaking hands are 5"H x 4.25"W. *Walters Collection.* $35-45 Other two $25-35.

BISQUE ANGELS AND CHERUBS

The world of Occupied Japan collectibles is heavily populated with angels and cherubs, and they are particularly breathtaking in some of the bisque centerpieces that have been found. These are pieces that serious collectors yearn for.

Some of the most exceptional angel and cherub figures appear with pottery marks and were more than likely fashioned for upscale gift shops. The fine details on these pieces include separated fingers and individually painted eyelashes.

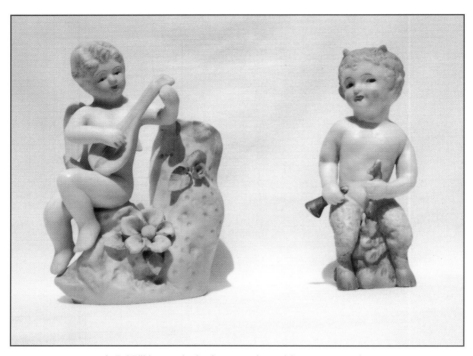

A 5.25"H angel playing a stringed instrument sits on a flower adorned vase. Mark #4 Andrea. $30-35. This cute little 5"H angel appears not to be so angelic since he is sprouting horns. Red MIOJ. *Gardner Collection.* $30-35.

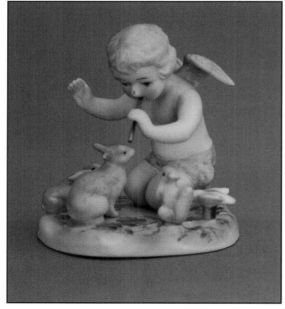

A delicately painted bisque cherub piping a tune to an audience of woodland animals. 4"H x 2.875" x 3.5". Marked Lamore China 544 MIOJ. *Bolbat Collection.* $40-50.

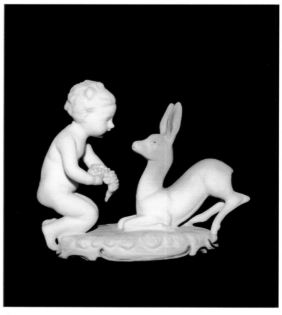

A bisque Putto kneels to feed a fawn. 4"H x 4.5"W. *Lange Collection.* $40-50.

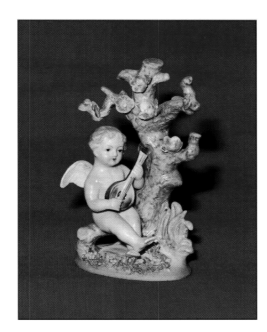

A bisque angel seated by a tree playing a flute. The branches have applied blue and pink flowers on them. 5.25"H. Andrea mark. *Agnew Collection.* $50-60.

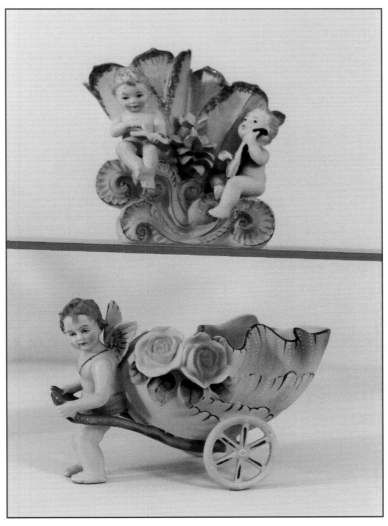

Top: Bisque vase with two figures playing musical instruments. The applied flowers are porcelain. Lamore China 590 MIOJ. 6.5"H x 6.5"W x 4.5" deep. $50-60.
Bottom: Bisque cart planter pulled by an angel. Moriyama. 5"H x 8"W. *Michalek Collection.* $50-60.

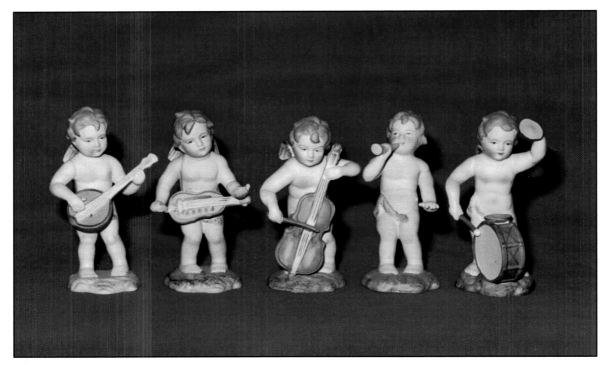

A five-member bisque angel band. All approximately 5.75"H.
They are marked Ardalt and lettered A through F. Should be
six but B is missing. *Agnew Collection.* $45-50 each.

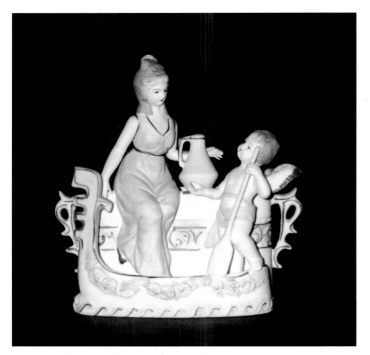

Bisque planter with an angel helping the lady at
the well. 7.125"H x 6.5"W. Mark #131 Red MIOJ.
Bolbat Collection. $55-60.

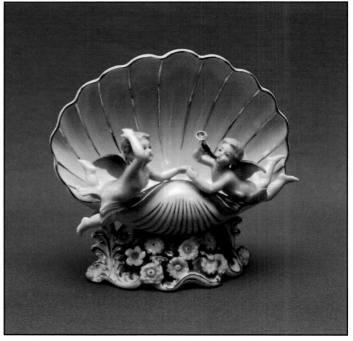

A wonderful 7"H shell with two angels on the
front. The base is covered with applied flowers.
Marked CHIKUSA. *Ferdinand Collection.* $65-75.

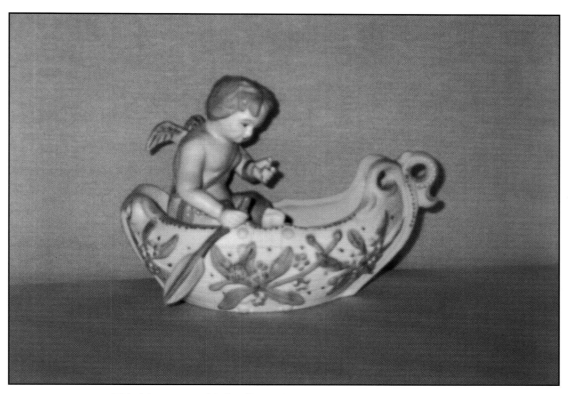

This bisque angel is busily rowing his boat. 4.5"H x 6"W. Mark #8 Lenwile China Ardalt #6276. *Walters Collection.* $65-75.

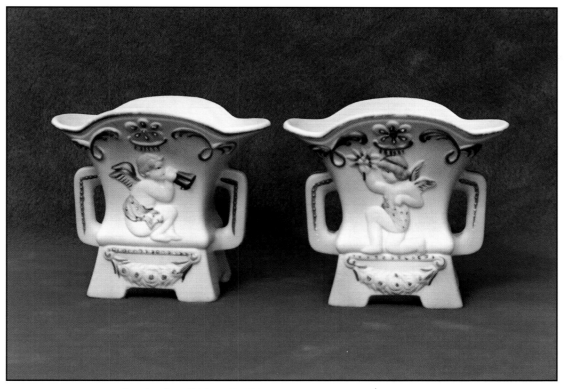

A pair of 3.5"H handled bisque vases with angels on the front. Mark #62 Moriyama. *Aycock Collection.* $50-60 pair.

BISQUE PAIRS

Paired figures made from bisque porcelain are among the more desirable forms that collectors hope to find. The bases on these figures match, indicating that they were, indeed, made for each other. Many were originally intended as lamp bases, but are equally attractive as figurines.

Some of the charm of bisque pieces is the soft pastel colors usually used to decorate them. Delicate coloring enhances their beauty and imparts an elegance that may be lacking on highly glazed porcelain figures.

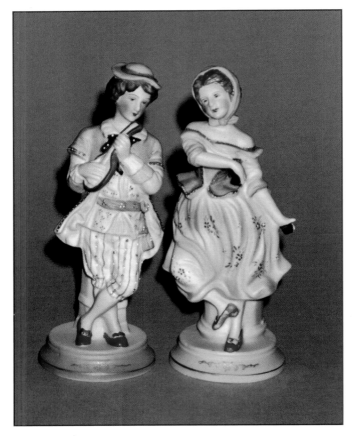

Top: A provincial man plays his flute while his mate prepares to perform a dance. Mark #8.
Lenwile China Ardalt with 6266A and 6266B. 6.75"H. *Bolbat Collection.* $100-125.

Bottom: A lovely pair of vases featuring a boy and a girl figure. They are adorned with gold beading. 6.5"H. Mark #70 Paulux. *Aycock Collection.* $100-125.

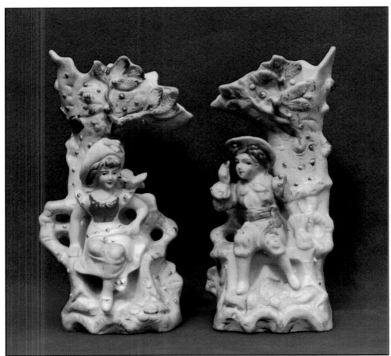

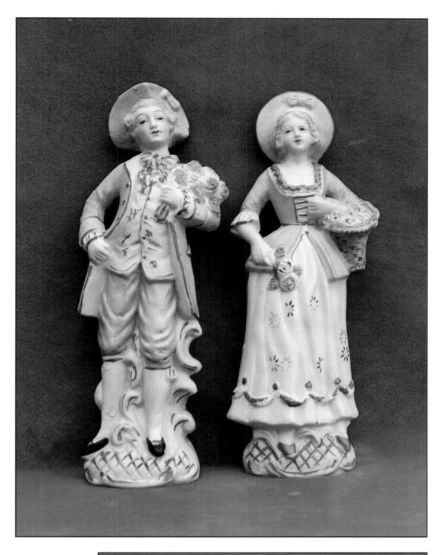

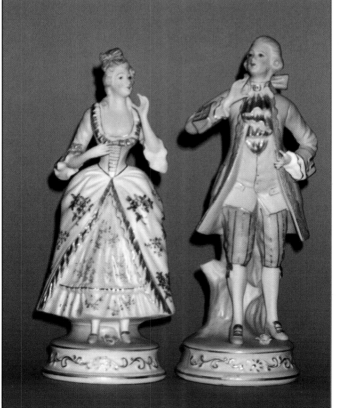

Top: A large 10.75"H man and woman carrying flowers. Black MIOJ.. *Aycock Collection.* $150-175

Bottom: A colonial pair standing in front of a tree stump. She measures 10.375"H and he measures 10.75"H. Mark #132 MIOJ. *Bolbat Collection.* $150-175

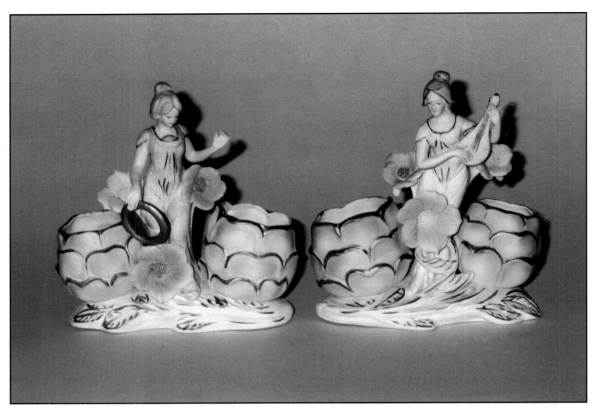

A pair of bisque lady vases is painted in reverse. 6.75"H
x 6"W. MIOJ in red. *Bolbat Collection.* $125-150.

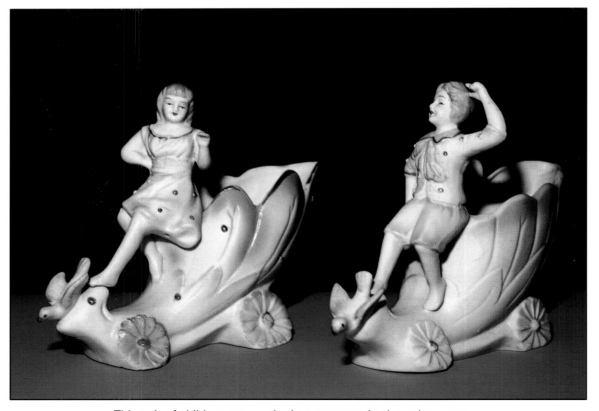

This pair of children are perched on cornucopia-shaped wagons
with flowers for wheels. A bird on the front leads the way. 4.875"H
x 6.875"W. Red Paulux mark. *Travis Collection.* $40-50 each

BISQUE GROUPS

Of particular interest to Occupied Japan collectors are bisque groups with several figures incorporated into them. Many are replicas of the beautiful Dresden and Meissen figure groups from Germany. Japanese makers were adept at copying the wonderful ceramic coaches and figurines of couples playing card games or partaking of afternoon tea, which had been produced years earlier by German pottery companies.

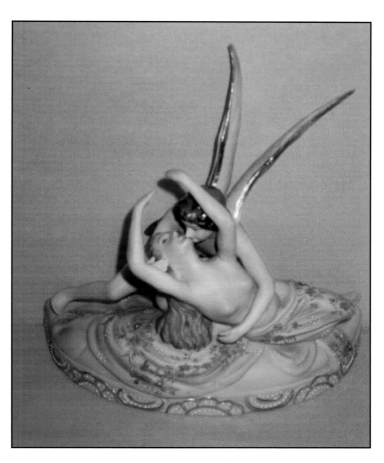

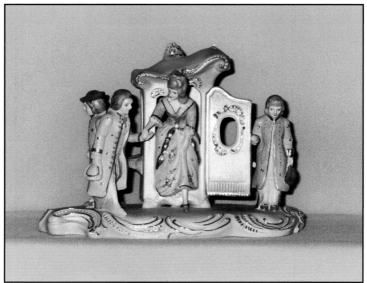

Top: This wonderful mythology figure was discovered on the base of a boudoir lamp. 7"H x 7.5"W. Mark #81 S.G.K. *Walters Collection.* $100-125.

Bottom: An unusual four-figured piece features a gentleman helping a lady descending from a sedan chair. One gentleman stands at the front while another holds the door. 6.5"H x 8.5"W. Mark #8 Ardalt. *Author's Collection.* $175-200.

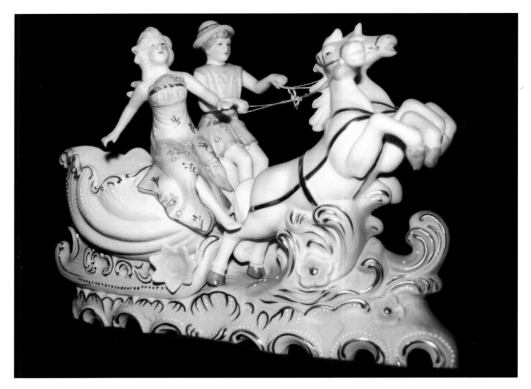

Top: This centerpiece with a Grecian couple driving two rearing horses also has a mate that is a mirrored image. 8"H x 13"W. Mark #4 Andrea. *Knighton Collection.* $400-450.

Center: A lovely lady plays the piano for her gentleman friend while her white cockatoo looks on. 6"H x 6"W. Mark #94 Gold Ucagco China. *Author's collection.* $60-75 each

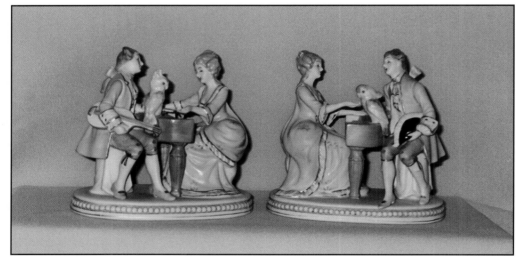

Bottom: Left: A gentleman offers to serve tea to the lady seated on a loveseat. 6.5"H x 5.5"W. Marked Handpainted – MIOJ – Andrea logo. Right: In this bisque planter the cherub is offering a dove to the Grecian lady at the well. 7.25"H x 7.75"W x 4" deep. *Agnew Collection.* $100-125 each.

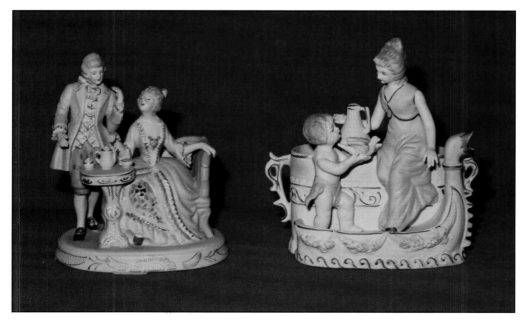

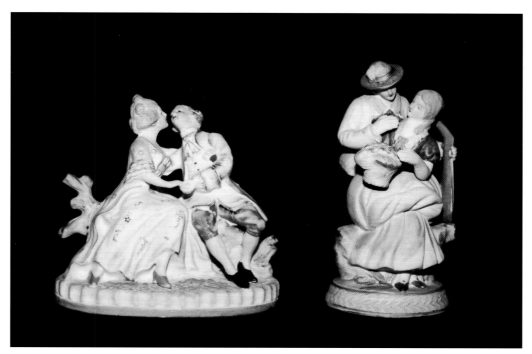

Left: An aristocratic courting couple are poised for
a kiss. 5.5"H x 6"W. Mark #107 LD.
Right: A farmer courts his lady. 6"H. Marked MIOJ.
Lange Collection. $75-100 each.

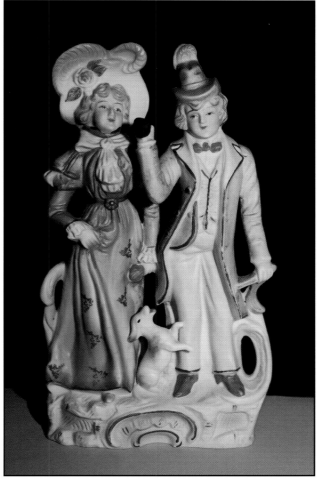

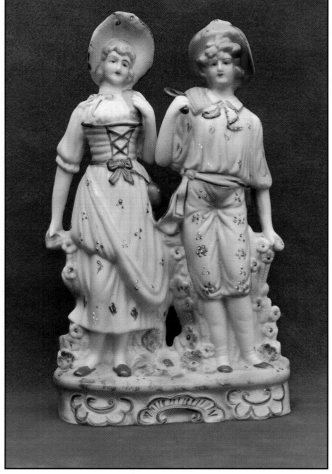

The dog in this figure is trying to attract the attention of
the gentleman. 9.5"H. Mark #62 plus Paulux all in red.
Paulux was the importer. *Author's Collection.* $75-100.

This 10"H pair on a single base suggesting a peasant
couple is exquisitely painted in pastels. He is holding a
small sickle on his right shoulder. Mark #4 Andrea.
Aycock Collection. $60-75.

VARIOUS BISQUE

Bisque pieces ranging from planters to religious statues abound.

The Infant of Prague is an exceptionally well made piece that was imported to the United States during the occupation era by the Lefton Company. It now takes its place in another realm of collecting, since a Lefton Collectors Club has recently been formed. Occupied Japan pieces can fall into a variety of categories that cross into several collecting fields.

The Elizabethan woman on her horse would be a great find for any collector. One wonders if there is a gentleman to match her. What a spectacular pair they would make!

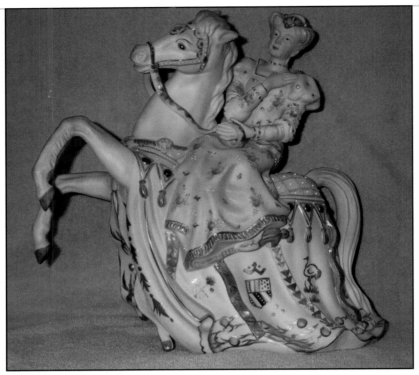

Top: This impressive Elizabethan woman sits sidesaddle on her rearing horse. Note the coat of arms on the horse's blanket. This is a truly large piece measuring 13.75"H x 14"W. Mark #7 Ardalt. *Page Collection.* $450-500.

Bottom: This boy in his top hat with his umbrella under his arm appears to be admonishing the cockatoo seated on a ball. 6.25"H x 4.375"W. Red Paulux MIOJ. *Travis Collection.* $65-75.

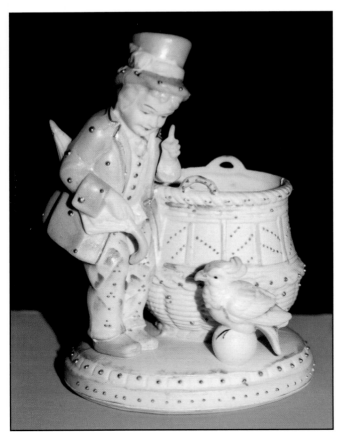

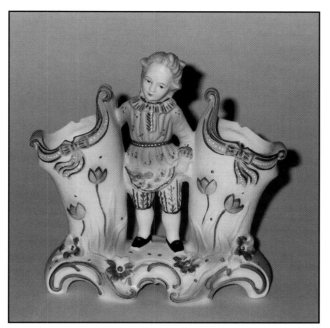

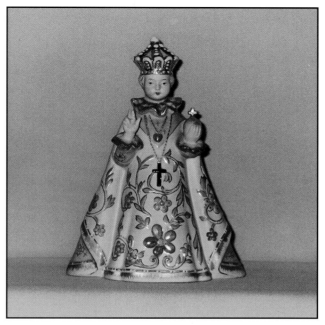

A bisque boy stands between two vases. 6.5"H x 6.5"W. Mark #4 Andrea. *Bolbat Collection.* $125-135.

A representation of the Infant of Prague marked with red cursive writing Made in Occupied Japan 716. 8.5"H. This also comes in a smaller size and was imported by the Lefton China Company. *Author's Collection.* $200-225.

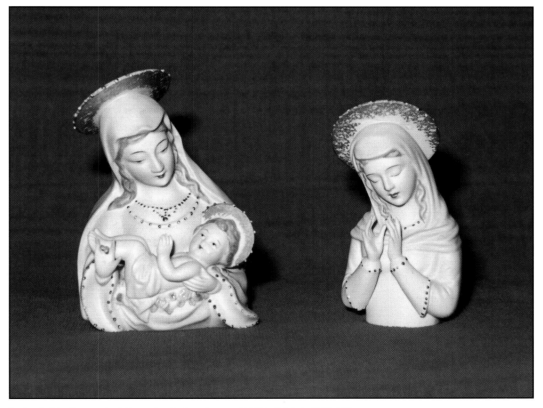

Left: A Madonna holding the baby Jesus. 5.5"H. MIOJ. $75-100.
Right: A praying Madonna has nicely crafted separate fingers. Marked LaMore China in script. 8"H. Agnew *Collection.* $50-75.

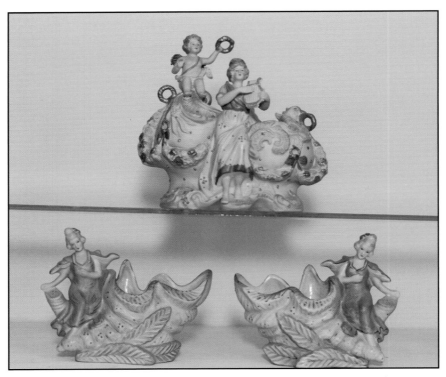

A trio of bisque planters. Top: A lady strums a harp while the angel on top brandishes a gold ring. 9"H x 9"W. Mark #71 red Paulux. $75-100.
Bottom : A mirrored pair of planters. 6.5"H x 7.5"W. One was purchased in San Francisco and the other from a club member in Connecticut, proving that it is possible to match pairs. *Michalek Collection.* $65-70 each.

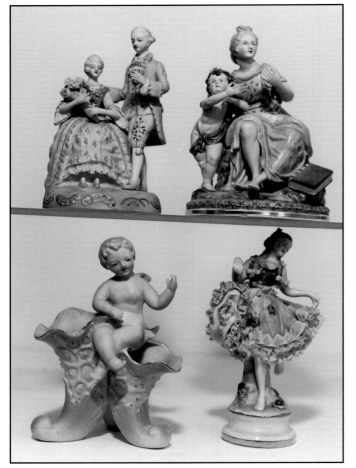

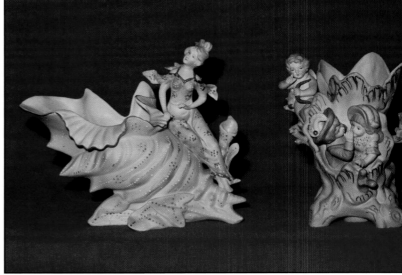

Above: Left: Lady in pink sits on the foot of a salmon colored shell. The inside is glazed in white and the piece is decorated all over with gold beading. 8"H x 7.5"W. Ardalt 6156 Registered. $100-125.
Right: A tree stump vase on which lovers whisper to each other while the cupid above prepares to shoot an arrow. 6.75"H. Ardalt 6177B. *Agnew Collection.* $75-100.

Left: A potpourri of bisque pieces. Top left: 7.5"H x 4"W. MIOJ. $65-75.
Right: 7.25"H x 5.5"W. Mark #4 Andrea. $75-100.
Bottom left: 7.5"H x 6"W. MIOJ. $50-60.
Right: 8"H x 4.5"W. MIOJ. *Michalek Collection.* $60-75.

ORIENTALIA

These mud people are typically Japanese and an example of fine workmanship. Both sets of dancers are nicely done. Some of these figures display traditional Japanese styles.

Figures were not just fashioned from ceramics, as these wooden pieces demonstrate. The left pair is fun. Into this category also falls the many dolls that were made for the Japanese doll ceremonies. They are elegant in their brocaded outfits and may have been made to replace those lost during the internment of Japanese Americans in the United States during the war years.

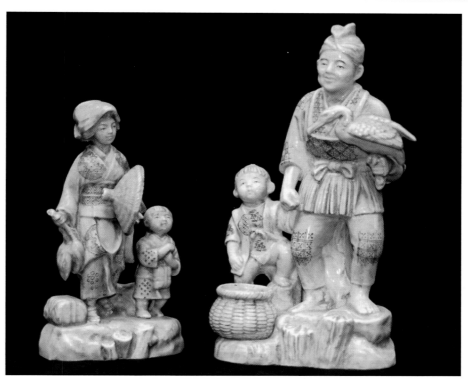

These porcelain mud people are so oriental looking. They are what you would expect to see when Japanese figures are mentioned. Left: Mother and daughter are 6.5"H. Mark #62 Moriyama in brown. $75-100. Right: A father and son with a water fowl. 8.5"H. Same mark. *Miller Collection.* $100-125.

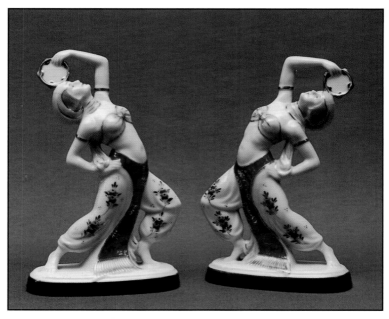

A pair of highly glazed exotic dancers. 8.25"H. Red MIOJ. *Ferdinand Collection.* $100-125 pair.

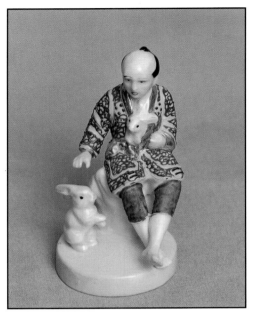

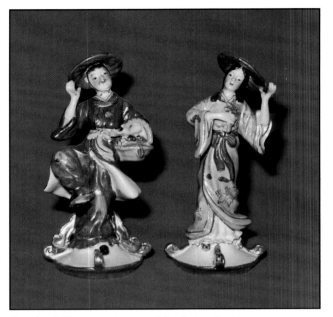

This oriental man with his rabbits is 4"H on a 2"W base. Mark #8. Ardalt Lenwile China. *Lushinsky Collection.* $35-40.

A pair of Siamese dancers highlighted with a great deal of gold decoration. 8"H. MIOJ. *Agnew Collection.* $60-75 pair.

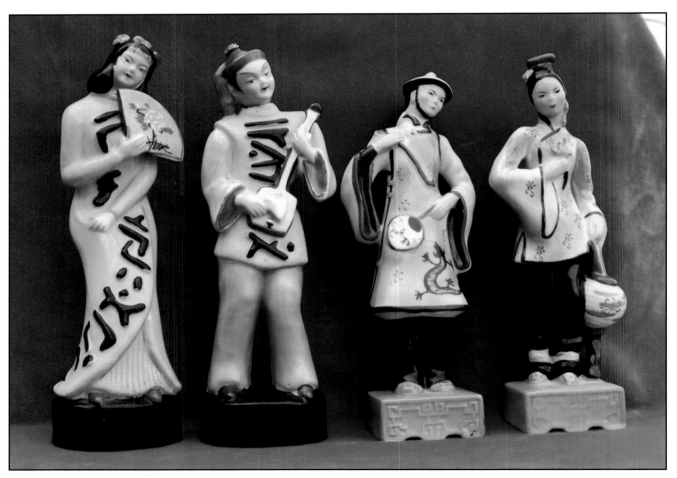

Two pair of oriental figures. Left: A lady fans herself while her companion plays a stringed instrument. 12"H. Marked Fancy China MIOJ. $100-125 pair. Right: The gentleman holds a fan while the lady carries a lantern. 11.5"H. Mark # 62 Moriyama. *Aycock Collection.* $100-125 pair.

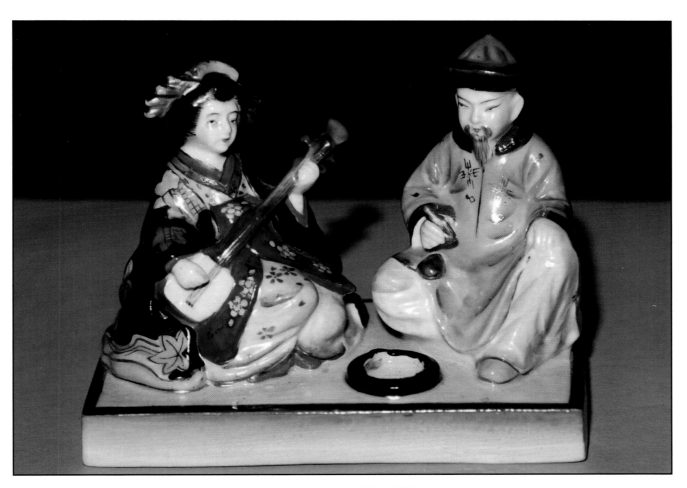

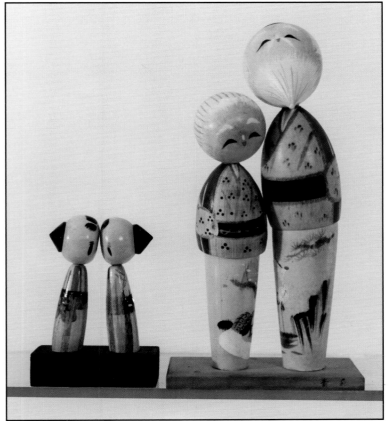

Above: This seated oriental lady serenades her mate with the Confucius beard. Could the receptacle in the front be for incense? 5"H x 5.75"W x 3.25" deep. Mark #107 LD. *Travis Collection.* $40-50.

Left: These two sets of figures are fashioned from wood. The left pair are loose in the base and when you take them out and replace them magnets in their heads cause them to turn and end up kissing each other. 3.75"H x 2.75"W. MIOJ. $35-40.
The pair on the right are made up of an older couple with white hair and a beard. 8.25"H x 4"W. MIOJ. *Michalek Collection.* $60-75.

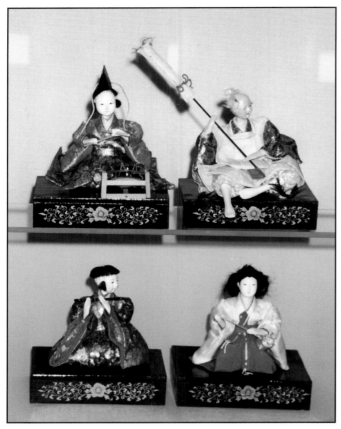

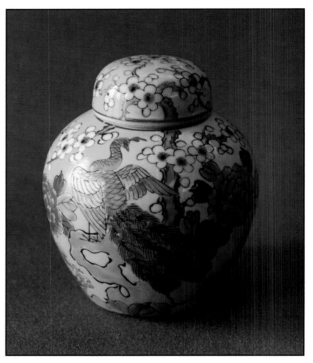

These four musician dolls are outfitted in brocade costumes and represent members of the Emperor's court. The top two are marked with a paper label. The bottom two are stamped MIOJ in purple ink. They all stand 5"H on a 3.75"W base. *Bolbat Collection.* $50-60 each.

A typical Japanese ginger jar stands 6"H. It is decorated with a crane and chrysanthemums. *Ferdinand Collection.* $35-40.

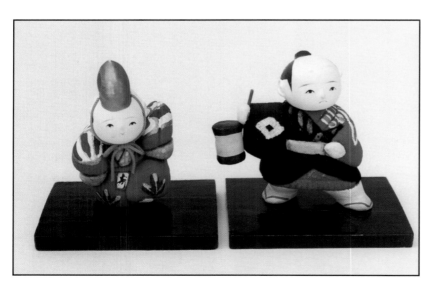

Above: These two 2.75"H oriental figures have porcelain heads and are clad in brocade clothing. They are mounted on black wooden bases measuring 2.125" x 2.75". Marked with a paper sticker. *Bolbat Collection.* $30-35 each.

Right: The sticker on the figures in the previous picture. *Bolbat Collection.*

CHILDREN FIGURES

If a collector were to limit themselves to figures of children marked "Made in Occupied Japan," they would be able to find many varieties, since Japanese manufacturers produced immeasurable numbers of these little people.

American Children continue to be a highly sought category in the Occupied Japan field and they are commanding big prices today, especially on the Internet. Other children figurines are also faithful copies of European originals, such as the German Hummel figurines with their nicely painted eyelashes.

Children are pictured doing all the usual things that children do, whether at school or at play. The cute little football player is quite unusual.

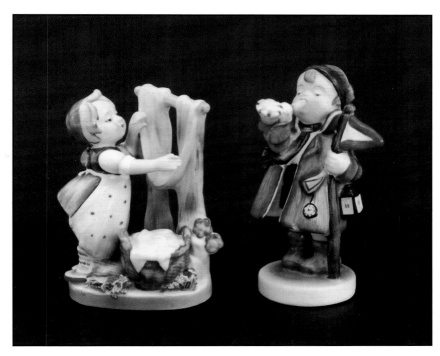

Two American Children. Left: "Washing" 4.75"H x 3.375"W x 2.125" deep. All marks are in black. $75-100. Right: "Night Watchman" 5.5"H. American Children and Night Watchman in red and Occupied Japan in black. *Bolbat Collection.* $75-100.

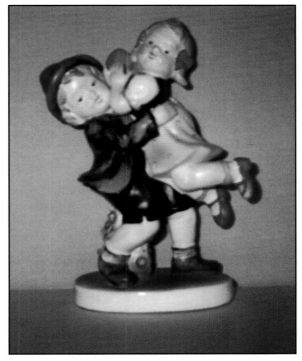

An American Children figurine with two children on one base. "Sweethearts". 7.5"H. *Walters Collection.* $75-100.

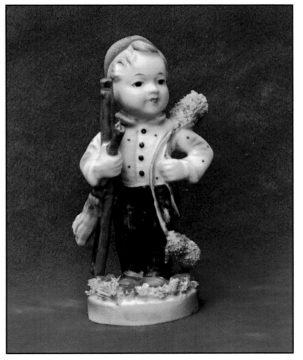

The "Chimney Sweeper" American Children figurine is 5.75"H. Marked all in black. *Aycock Collection.* $75-100.

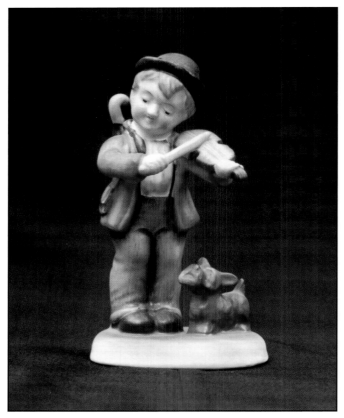

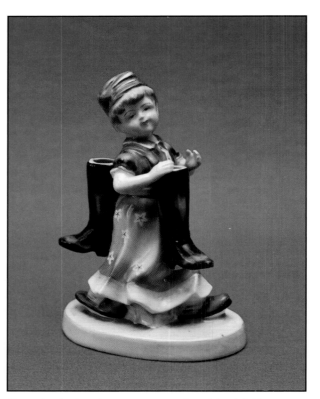

This American Children statue is appropriately entitled "Fiddler and Dog" and was discovered after the checklist was published in *Occupied Japan for Collectors*. It is 5.5"H. *Miller Collection.* $75-100.

If you look closely you can see that this child is wearing a dress. At first glance one would think it was a boy carrying those big boots over his shoulder. The tops of the boots are open. 6.25"H. Mark #107 LD. *Ferdinand Collection.* $35-40

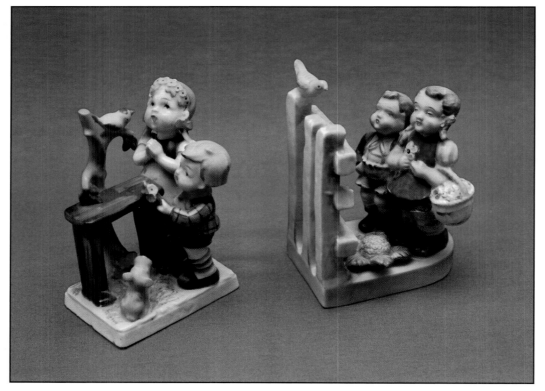

Left: Two children listen to a bird sing while their dog looks on. 5.5"H. Blue green MIOJ. $35-40.
Right: One half of a set of bookends shows a similar pose. The girl has a basket on her arm. 6"H. Mark #21 elephant head. *Ferdinand Collection.* $35-40.

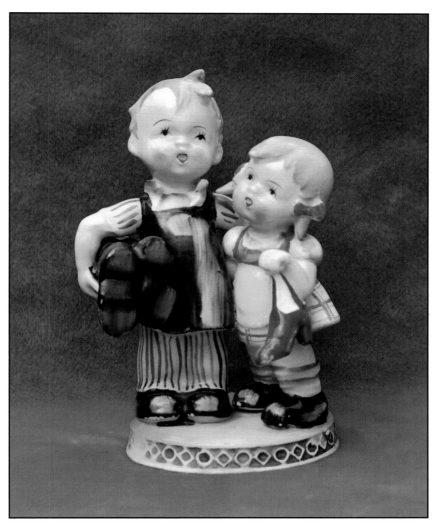

A Hummel-like figure pictures a boy with a pair of shoes under his arm while the girl holds a red shoe. 6.25"H. MIOJ in green. *Aycock Collection.* $50-60.

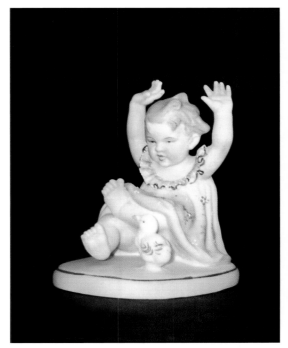

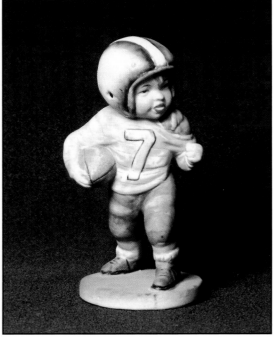

This lovely bisque baby is playing "So Big" while a baby duck looks on. 4.5"H x 4.375"W. Mark #62 Moriyama in red. *Bolbat Collection.* $45-50.

A chunky bisque football player is prepared to run with the ball. 6.5"H. Marked with an R in a shield surrounded by a green MIOJ. *Hearn Collection.* $35-45.

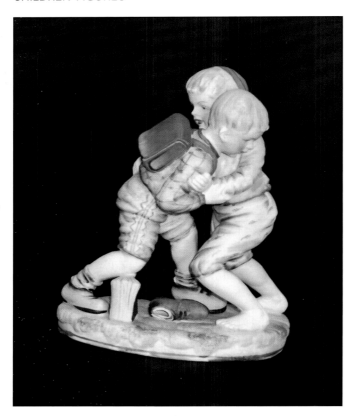

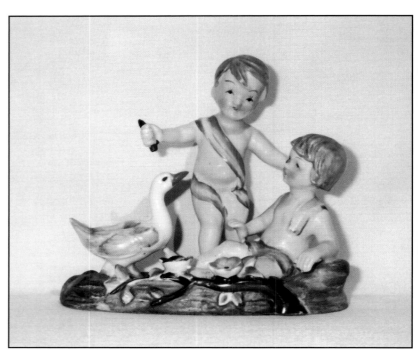

Top left: Two bisque school-boys are engaged in a wrestling match. One has lost his shoes and the other has dropped a book. 8.5"H x 7"W. Mark #107 LD. *Bolbat Collection.* $225-250.

Top right: This lovely porcelain figurine with two boys and a waterfowl is 4.5"H. Blue green MIOJ. *Gardner Collection.* $40-45.

Right: A lovely porcelain boy with a peg leg is a copy of the Meissen "Cupid as Beggar" and has his leg bent at the knee and behind him. 8.25"H x 3.75"W. Mark #4 Andrea. *Bolbat Collection.* $150-175

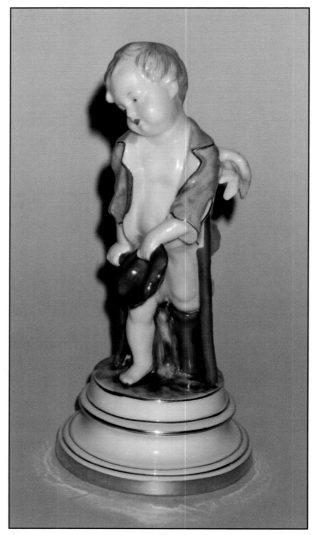

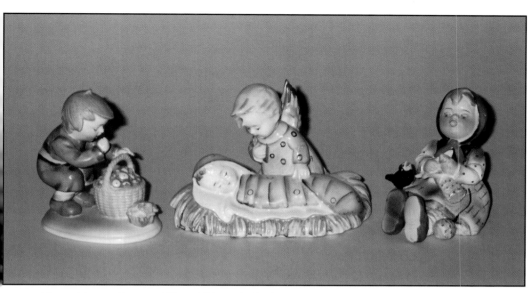

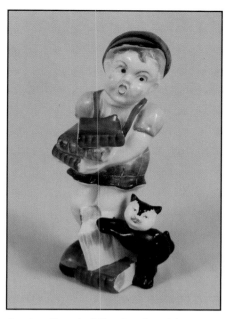

Three bisque Hummel-like children. Left: Boy eating apples.
4.25"H x 3.75"W. Mark #21 Elephant. $35-40.
Middle: A copy of the Hummel "Angelic Sleep" figure. 4.25"H
x 5.75"W x 3.5" deep. $35-40.
Right: The girl knitting is a copy of the Hummel "Happy
Pastime" and is 4"H x 3.25"W. MIOJ. *Bolbat Collection.* $35-40.

A schoolboy holding books with
a black cat at his feet stands on
a book he has dropped. 9.5"H x
4.5"W. Mark #107 LD plus Hand
Painted. *Straight Collection.*
$50-60.

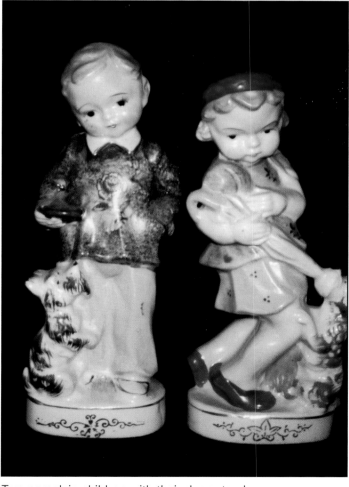

Two porcelain children with their dogs stand
8"H. MIOJ. *Lange Collection.* $35-40.

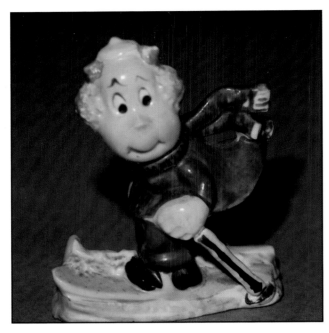

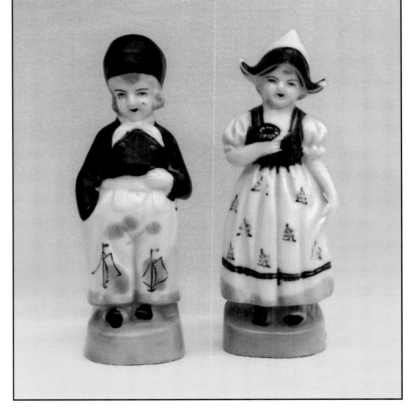

Above: Could this be Little Lulu? This skier is 4"H. Black MIOJ. *Travis Collection.* $30-35.

Right: These two children are typical Dutch Delft pieces. He has sailing ships on the front of his pantaloons. 6.5"H. Blue MIOJ. *Aycock Collection.* $45-50 pair.

ANIMALS AND BIRDS

Japanese makers produced not only tiny birds, as found in dime stores in the early 1950s, but also large and beautiful bisque birds, as the extraordinary ones shown demonstrate.

Animal statues cross many collecting fields, yet the numbers exported were so vast that today there seem to be sufficient quantities to satisfy all the various collectors. Many of these are replicas of European originals.

Collectors are fortunate when tiny glass animals are found with their labels intact. There must be hundreds remaining now that have lost their tags and cannot be authenticated as Occupied Japan.

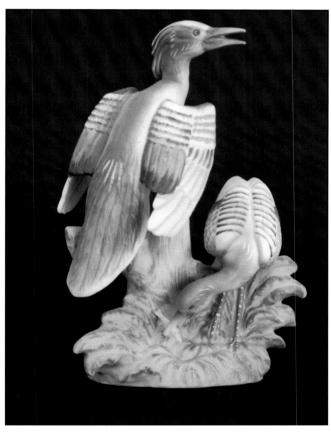

Left: One of these two bisque birds on a single base is feeding on a fish he has caught while the other is perched on a tree stump. 8.25"H on a 4" x 2.75" base. Mark # 94, only the Ucagco China and MIOJ are in green. The logo is black. *Bolbat Collection.* $100-125

Below: This magnificent bisque falcon measures 12"W x 7.5"H x 6.5" deep. Red MIOJ. *Bolbat Collection.* $350-400.

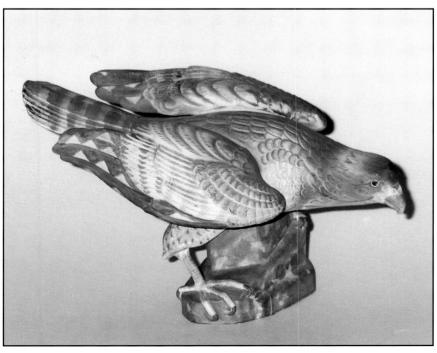

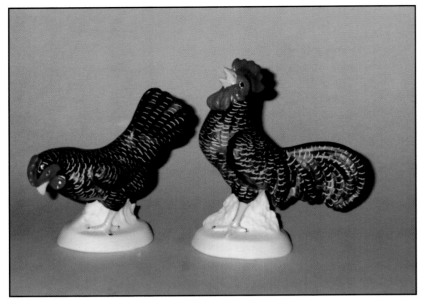

The rooster in this bisque pair seems to have found something to crow about while his mate is looking for a snack. The hen is 4.5"H x 4.75"W and the rooster is 5.5"H x 4.75"W. Mark #182. *Bolbat Collection.* $60-70 pair.

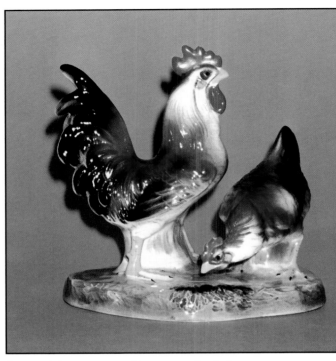

A porcelain rooster and hen on a single base measures 5.375"H x 5"W. Mark #88 T in a circle. *Bolbat Collection.* $35-40.

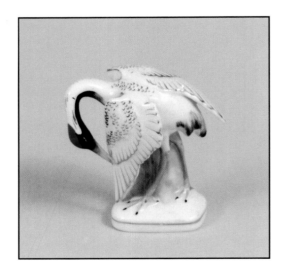

Left: A white stork with gold trim has an orange and black head. 3.75"H x 3.5"W. Mark #107 LD. *Straight Collection.* $15-20.

Below: Three glass animals that have retained their paper labels. Left: A blue long tailed bird is 2"H x 5"W. Middle: A pink fish is .75"H x 2"W. Right: A pearlized monkey is 1"H x 2"W. *Lushinsky Collection.* $10-12 each.

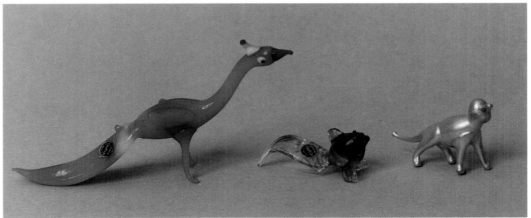

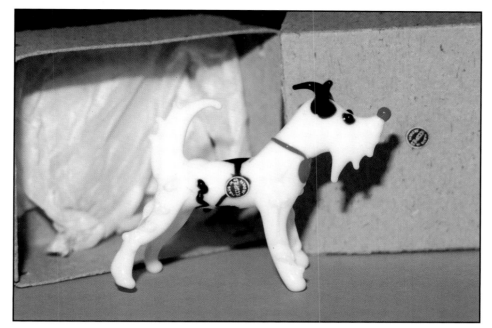

A white glass dog with his original box. 2.875"H x 3"W. Both the box and the dog are marked. *Travis Collection.* $12-15 with the box.

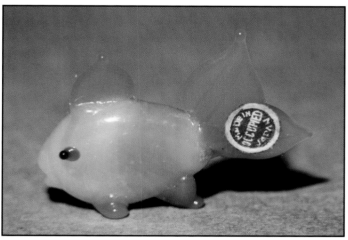

A pink fish with blue tail and fins measures .875"H x 1.25"W. It clearly shows the paper label that marked most of the mini glass animals. *Travis Collection.* $10-12.

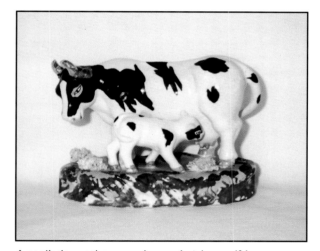

A realistic mother cow is nursing her calf in this figure. 4"H x 6"W. Red MIOJ. *Gardner Collection.* $40-45.

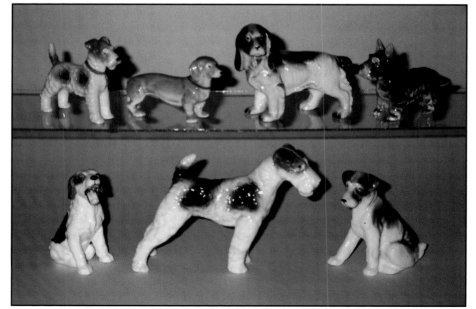

A pack of highly glazed dogs representing many breeds. All have Mark #88 T in a circle. Top: These measure from 2.625"H to 4.25"H x 4"W to 5"W. $20-25. Bottom: 3.5"H to 5.75"H. The center dog is 7.5" long. *Bolbat Collection.* $30-35.

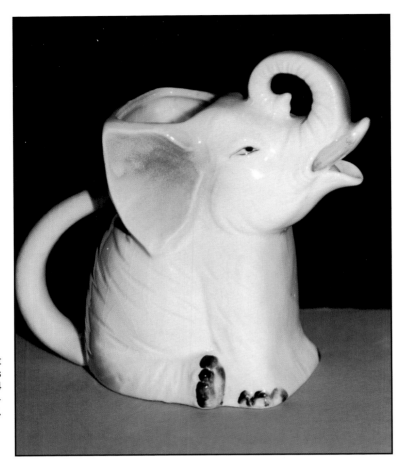

This unusual elephant creamer stands 4.875"H. Mark #94 Ucagco. *Travis Collection.* $25-30.

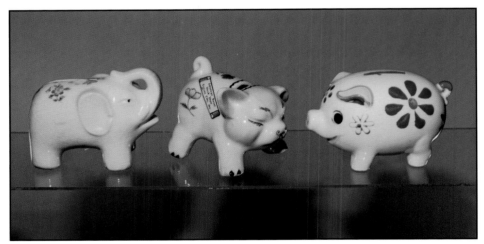

Three charming banks beckon the collector to fill them with coins. Left: An elephant measures 2.875"H x 3.75"W. Black MIOJ. Middle: This piggy bank is 2.875"H x 3.5"W with a red MIOJ. The souvenir sticker on the side reads "American Royal Stock Show Kansas City MO."
Right: A smiling pig is 2.625"H x 3.75"W with a black MIOJ. *Travis Collection.* $25-30 each

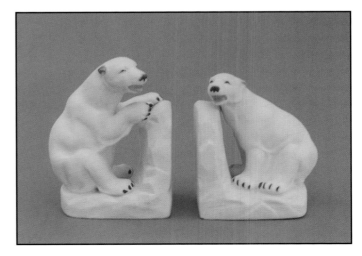

Bisque polar bear bookends. 5.125"H x 3.875"W. Marked Ucagco. *Bolbat Collection.* $55-60.

LAMPS AND CANDELABRA

Some of the more common Occupied Japan lamps feature pairs of Colonial attired men and women figurines that were manufactured in Japan and sent to America, intended to be fashioned into lamps. Some of the figurines were never mounted as lamps, and others have been removed from their original bases.

Some pairs of lacquerware lamps are breath-taking, such as those shown. The marvel is that they are in such good condition and that their globes are still intact.

The cobalt blue lamps are a stunning pair, proving that all that came from Japan in this era was not inferior.

The unusual 11-inch high blue glass lamp is another stunning piece. Japanese manufacturers made lamps intended for use in various rooms, from the kitchen to the children's nursery.

Candelabra were often made in bisque. They would make a lovely addition to a collector's dining room today. Shown are typical as well as ornate candelabra.

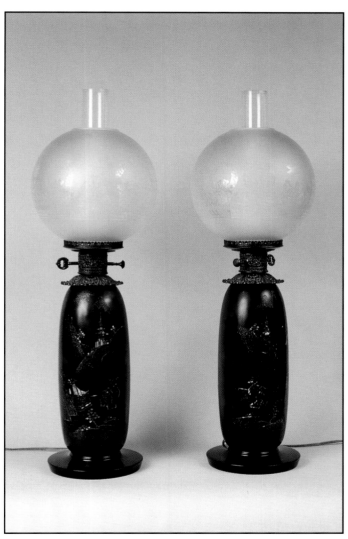

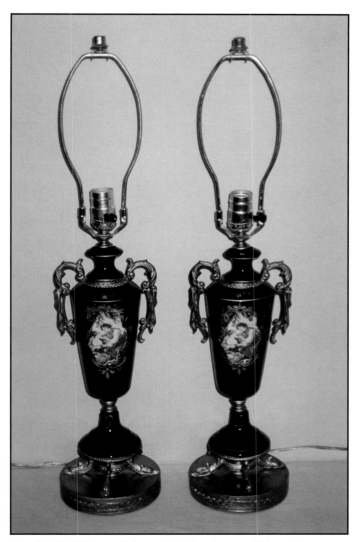

These Victorian style lacquerware lamps are the most spectacular I have ever seen. They measure 28"H including the chimney. They are topped with opaque glass globes with a clear glass design of flowers, wreaths, and bows that do not show up in the picture. The width of the bases is 6.75". Mark #51 in gold. Maruni Lacquerware. *Anonymous Collection.* $400-450 pair.

A pair of 16"H porcelain cobalt blue lamps. Although bought as a pair the decorations are not mirrored images. Mark #62 Moriyama. *Walters Collection.* $175-200 pair.

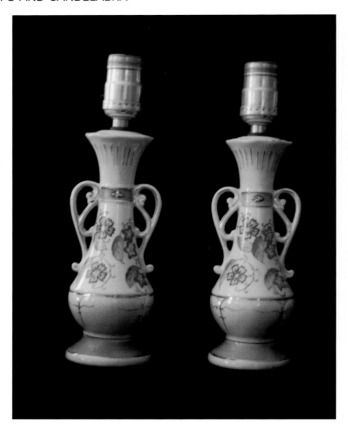

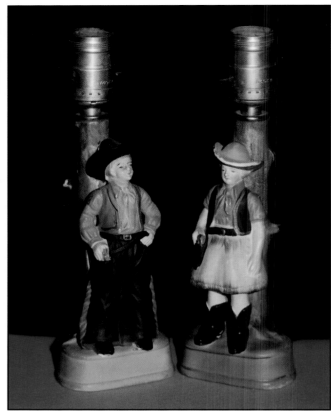

Top left: This pair of parlor lamps are decorated with flowers and have applied curlicues for handles. They stand 11"H including the sockets. MIOJ. *Lange Collection.* $100-125 pair.

Top right: A pair of bisque lamps for a child's room representing a cowboy and a cowgirl. Measuring 10.25" to the top of the socket they are marked Hand Painted MIOJ. *Travis Collection.* $100-125 pair.

Right: Flamingo dancers adorn this pair of lamps. 12.75"H and marked MIOJ Sample in cursive writing. *Michalek Collection.* $60-75 each.

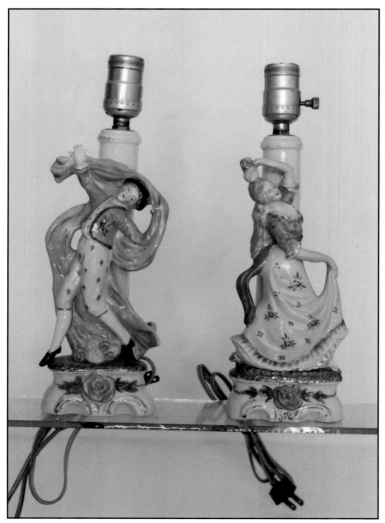

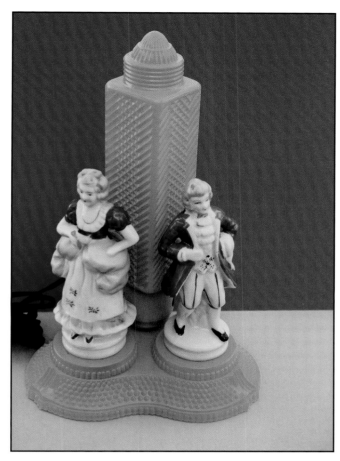

Left: This unusual blue glass lamp with its pair of Colonial figures stands 11" tall. The figurines are 6" tall and marked MIOJ. The lamp base is not marked. *Smith Collection.* $55-65.

Below left: An interesting kitchen wall lamp features a cook preparing a meal. It is 6.375" in diameter. Red MIOJ. *Travis Collection.* $40-50.

Below: An intriguing night light made from a wall plaque is 6.25" x 5.25". MIOJ. *Michalek Collection.* $60-65.

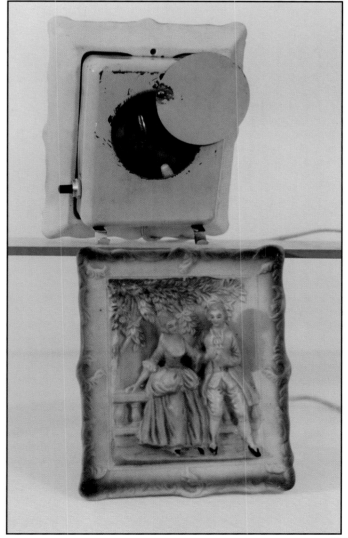

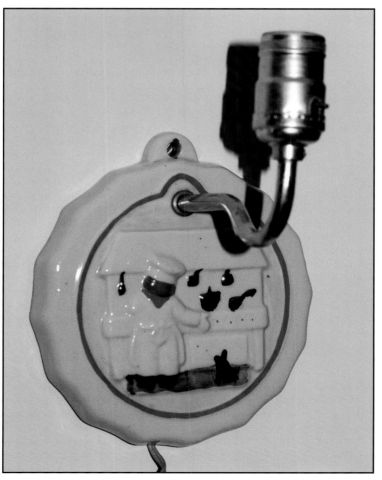

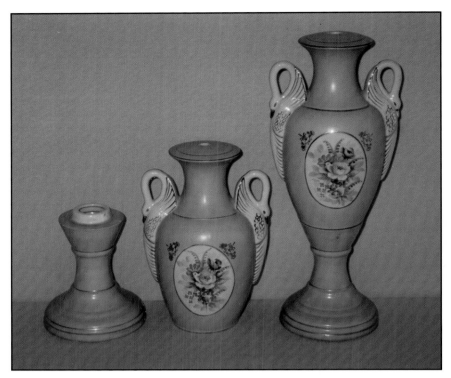

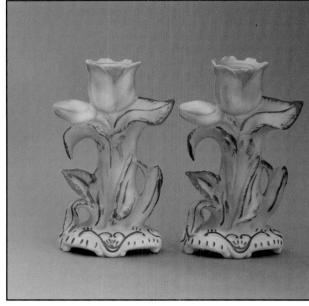

Above: These lamp bases came Mint In Box and were apparently never fashioned into lamps. They are 13"H and the box and both pieces are marked with a black MIOJ. They came in four colors, light green, wine, pale yellow, and the light blue shown here. *Walters Collection.* $65-75 pair.

Right: A lovely pair of pink tulip bisque candle holders. 7"H x 3.625"W. Red MIOJ. *Bolbat Collection.* $100-125 pair.

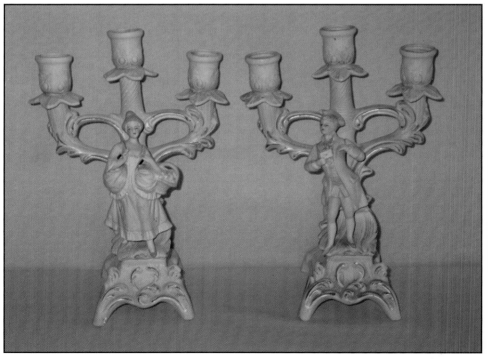

An exceptional pair of bisque candelabras. They are 9.5"H and measure 5" in width across the top. Mark #4 Andrea. *Walters Collection.* $150-175 pair.

CLOCKS

Many of the porcelain clocks found today marked "Made in Occupied Japan" are composed of Japanese-made housings with works that were incorporated in America. Shown are some of the most extraordinary ones known. They are found with both wind-up and electric works. Any collector should be delighted to have one.

The Occupied Japan field embraces useful items as well as decorative arts, as demonstrated by alarm clocks and more prosaic wooden clocks. They all tell the time, some in fancier rooms than others.

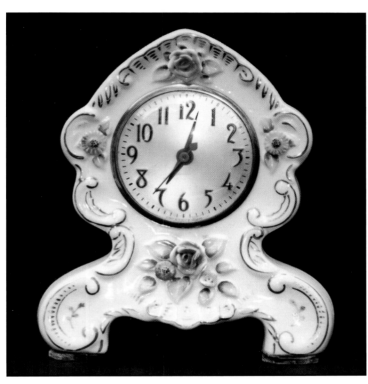

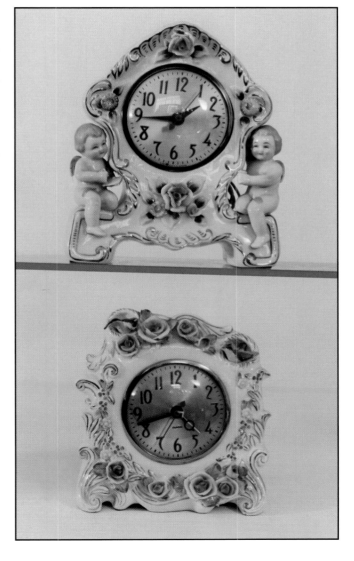

Above: An ornate porcelain clock is embellished with applied flowers. The face reads "Clock Movement by Sessions" and it stands 8"H. Mark #81 S.G.K. *Miller Collection.* $100-125.

Right: Both clocks have Sessions' movements. Top: Two angels are perched on either side of this porcelain clock. 7.75"H x 6.75"W. mark #81 S.G.K. $125-150.
Bottom: Lovely porcelain table clock is 6.75"H x 6.25"W. It is marked S.C. China with a gold logo. *Michalek Collection.* $100-125.

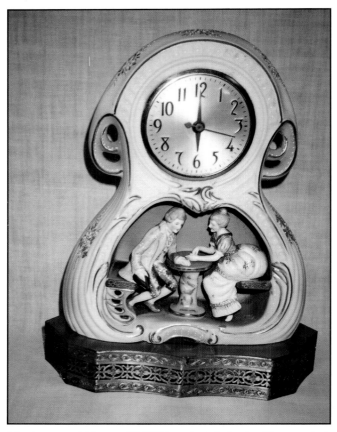

Most unusual bisque 10.25"H pedestal clock with a seated Colonial man and woman in the center. Double marked S.G.K. and MIOJ. *Crum Collection.* $250-300.

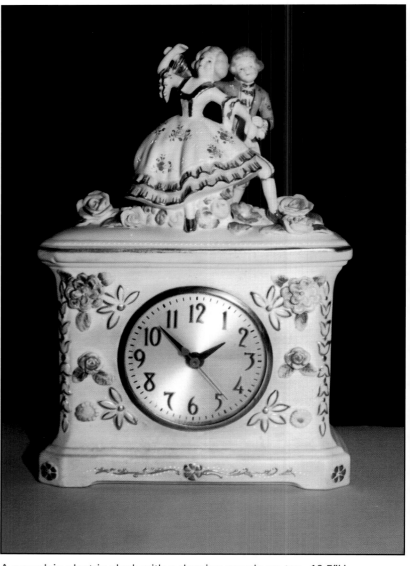

A porcelain electric clock with a dancing couple on top. 10.5"H x 7.125"W. Mark #81 S.G.K. *Travis Collection.* $250-300.

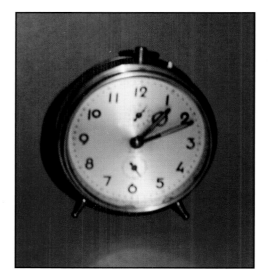

A most interesting chrome alarm clock. It is marked in small block letters "Meiji" and MIOJ under six o'clock. 4.75"H. *Bomba Collection.* $75-85.

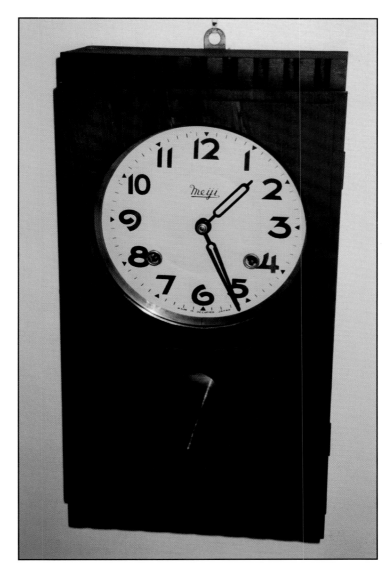

Top: A wood encased pendulum clock marked Meiji. The MIOJ is under the 6. 16"H x 9"W. *Walters Collection.* $300-350.

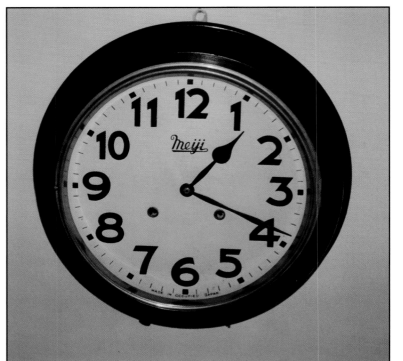

Bottom: Another Meiji manufactured clock for the wall in a wooden case. 16" in diameter. Marked MIOJ under the number 6. *Walters Collection.* $75-85.

WALL POCKETS AND PLAQUES

Since the days of cave dwelling, humans have been compelled to decorate the walls of their abodes. Occupied Japan wall pockets and plaques offer great variety and an opportunity to decorate, no matter where your taste lies.

The wall pockets and plaques shown cover many styles intended for use in any room of the house. Of special interest is the one made from seashells.

Top: This very Oriental looking wall vase has a red clay body. 5.375"H x 2.375"W. Impressed Made in Occupied Japan Nishikawa Kyoto. *Bolbat Collection.* $30-35.

Bottom: A pair of wall pockets featuring a French lady holding her skirt with doves on her left arm and a gentleman with a tri-cornered black hat reaching out towards a dove. They have a hole in the back to hang. 7"H x 3.75"W. Red MIOJ. *Author's Collection.* $40-45 pair.

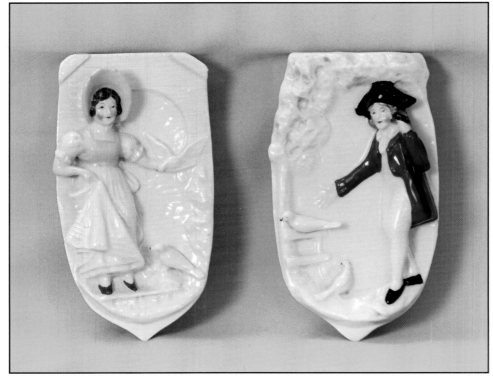

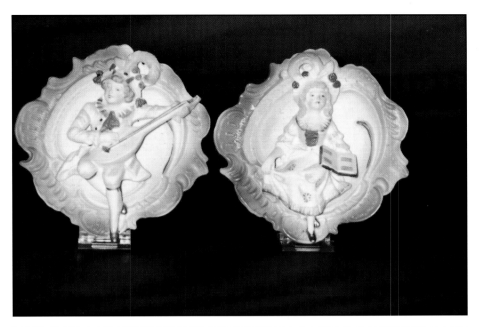

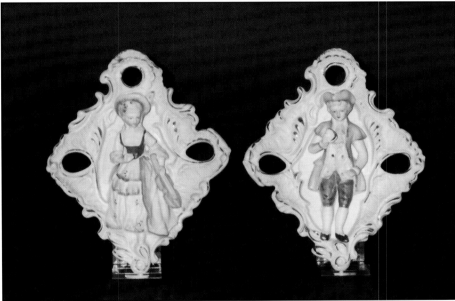

Top: A musical couple on a pair of bisque plaques. 6.25"H x 6"W. Marked Occupied Japan in red. *Bolbat Collection.* $75-80 pair.

Center: A pair of diamond shaped bisque plaques with a Colonial man and woman. 7.75"H x 5.875"W. Mark #15 Chase. *Bolbat Collection.* $75-80 pair.

Bottom: Butterfly shaped hanging wall plates. 5"H x 6.5"W. Mark #16 Chubu China. *Ferdinand Collection.* $35-40 each.

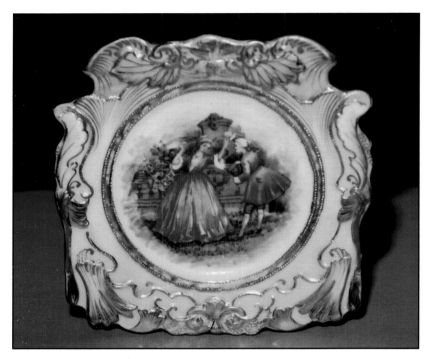

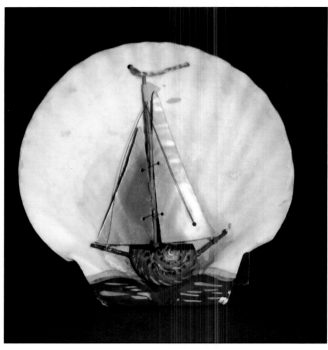

A small wall plaque with a pastoral scene measuring 4" x 4". Handpainted MIOJ. *Travis Collection.* $25-30.

This wall plaque is made entirely of seashells. 4.5"H x 4.5"W. Black MIOJ. *Travis Collection.* $35-40.

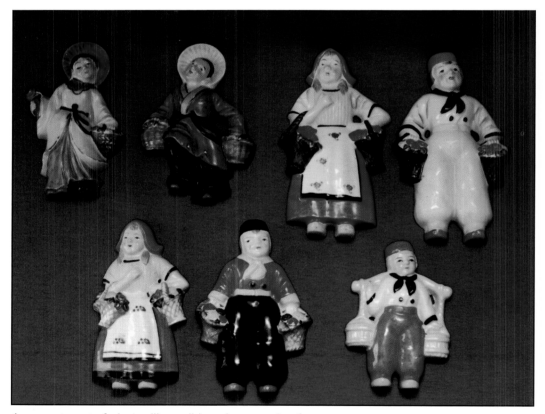

An assortment of plaster-like wall hangings ranging from 4.75"H to 5.25"H. All have Mark #101 Yamaka MIOJ. *Ferdinand Collection.* $35-45 pair.

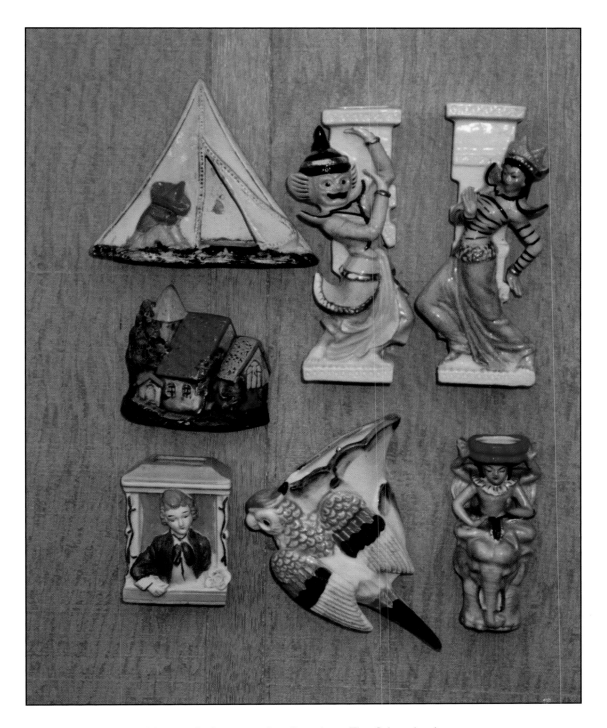

More wall plaques and wall pockets. The Oriental pair are
6.75"H. The teepee and the house have Mark #127 Raised
MIOJ and all the others are marked with a black MIOJ.
Walters Collection. $17.50-20 each.

DECORATIVE PLATES

Many of the decorative plates imported to America display the Japanese artists' talents for painting exquisite scenes. Some are artist signed. Most have holes on the back so that they can be hung on the wall. The ones with the Chubu mark (#16) invariably are decorated with an abundance of gold and are very elaborate. Scenes range from landscapes to flowers to portraits. They are all nice additions to a collection.

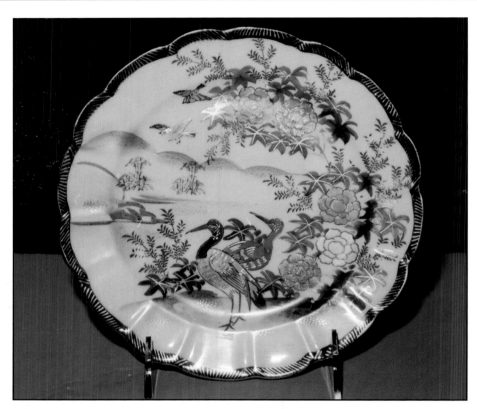

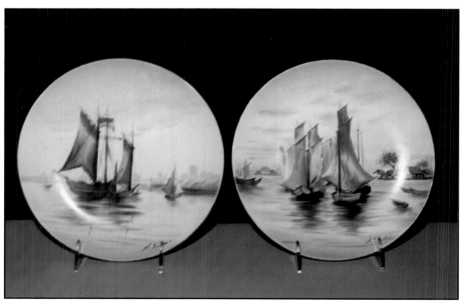

Top: A decorative plate made of fine china with a typical Japanese crane motif. It is 7.375" in diameter and has Mark #8 Lenwile China Ardalt 6193. *Travis Collection.* $45-50.

Bottom: A pair of ship plates, 9.25" in diameter with Mark #198. *Travis Collection.* $35-40.

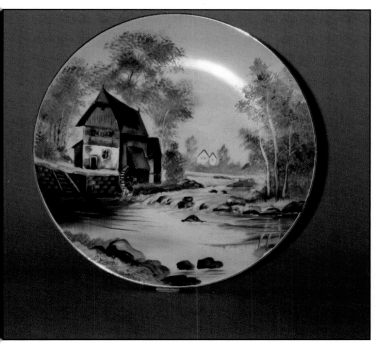

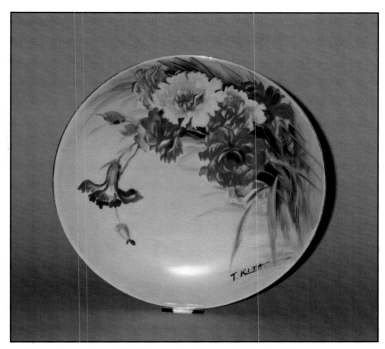

A scenic plate showing a water wheel. Signed on the front and measuring 9″ in diameter with Mark #146. *Bolbat Collection.* $35-40.

A floral plate signed T Kita on the front. It is 9.875″ in diameter and has Mark #177. *Bolbat Collection.* $35-40.

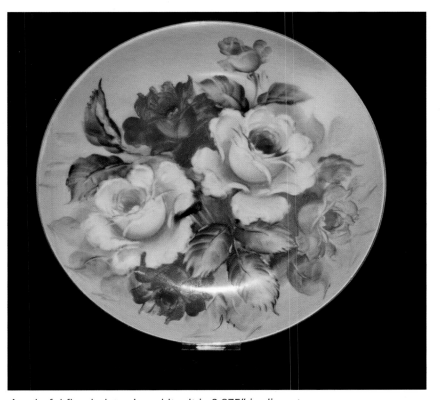

A colorful floral plate signed Ito. It is 9.875″ in diameter and has Mark #177. *Bolbat Collection.* $35-40

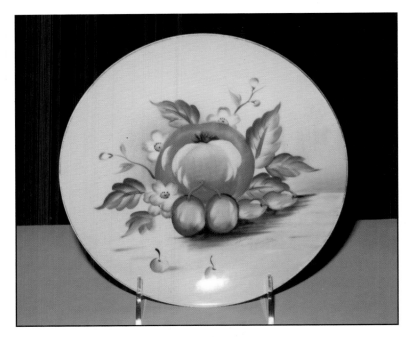

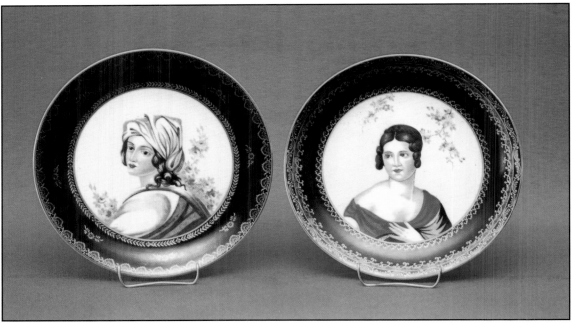

Top: An 8" wide fruit plate marked with Mark #14 Celebrate. *Travis Collection.* $25-30.

Center: These two plates depicting Beatrice Cenci and Pauline Bonaparte are copies of an Italian series. They are nicely edged in black and gold. 9.5" in diameter. Mark #81 S.G.K. *Ferdinand Collection.* $50-55.

Bottom: A reticulated edged plate with a Grecian pastoral scene. 9.25" in diameter with Mark #81 S.G.K. *Bolbat Collection.* $50-55.

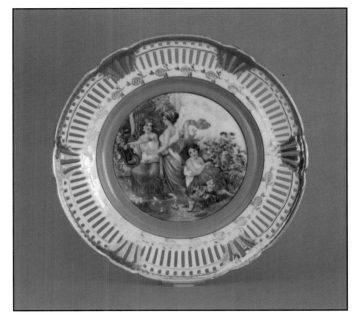

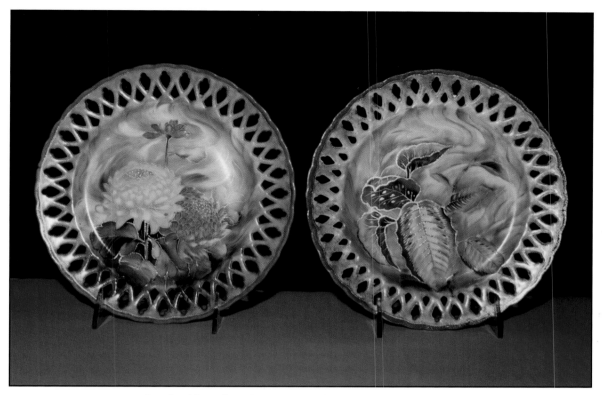

A pair of heavily gold decorated floral plates. 8.25" in diameter with Mark #16 Chubu. *Travis Collection.* $45-50.

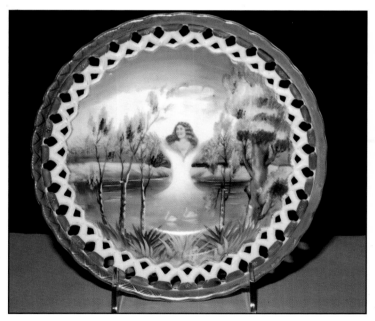

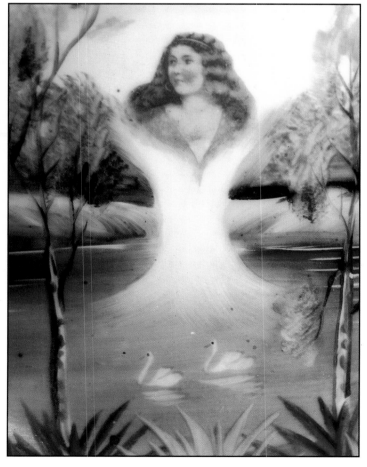

Above: A wonderful plate depicting the Lady of the Lake. 8" in diameter with Mark #16 Chubu. *Travis Collection.* $45-50.

Right: A detail of the Lady of the Lake.

VASES AND PLANTERS

Occupied Japan vases and planters come in a variety of sizes and shapes. They can be made from bisque or porcelain, and have been found in gift shops and dime stores. Many vases and planters were bought by young children years ago as thoughtful gifts for their mothers. Some were fashioned for florists to use in enhancing their arrangements, yet all have a utilitarian as well as a decorative use.

The bisque examples shown are just a few of the many that were originally sold in fine gift shops while others represent the more ordinary styles that "Made in Occupied Japan" or "Made in Japan" recall to many who lived during the early 1950s. They all can have a place in our collections.

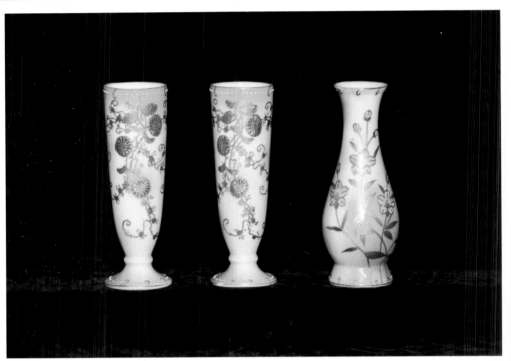

Three peach colored lovely bisque vases with lots of gold ornamentation. 7.25"H. Mark #85 Shofu China plus Ardalt 6113. *Hearn Collection.* $60-65 pair and $30-35 single.

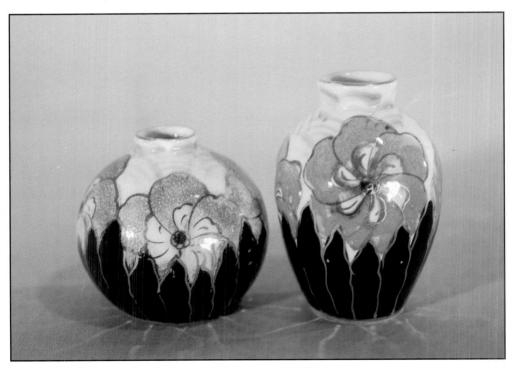

A pair of typical Japanese ware vases. 2.5"H and 3.25"H. Mark #89 T over M. *Bolbat Collection.* $18-20 each.

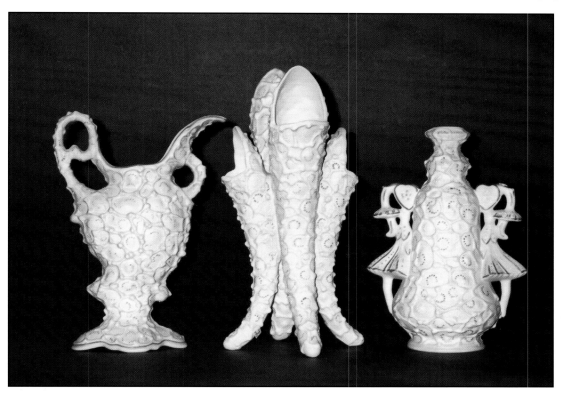

These three pale green bisque pieces all have the same nubbly finish.
Left: The pitcher is 8.75"H. Middle: A 10.5"H fish vase. Right: Although
this bottle is missing its stopper it is still a nice piece. 8.25"H. All have
mark #8 Ardalt plus numbers. *Bolbat Collection.* $75-90 each.

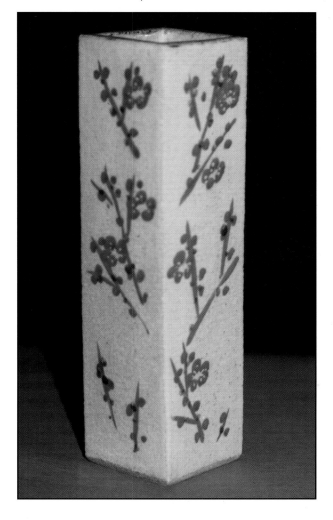

Left: An interesting square vase is 12.25"H
and 3.125" square. It is marked with MIOJ
and a mountain. *Travis Collection.* $50-75.

Above: The bottom of the square vase also
shows the customs' sticker.

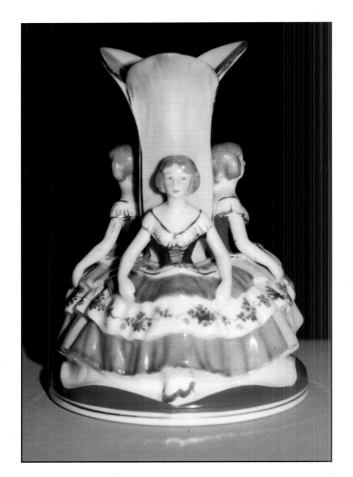

Right: Three ladies in their ball gowns sit around this vase. 6.5"H. Red MIOJ. *Travis Collection.* $55-65.

Below: An 8.25"H pair of flowered vases. The picture shows both the front and the reverse. Mark #23 elephant. *Miller Collection.* $125 pair.

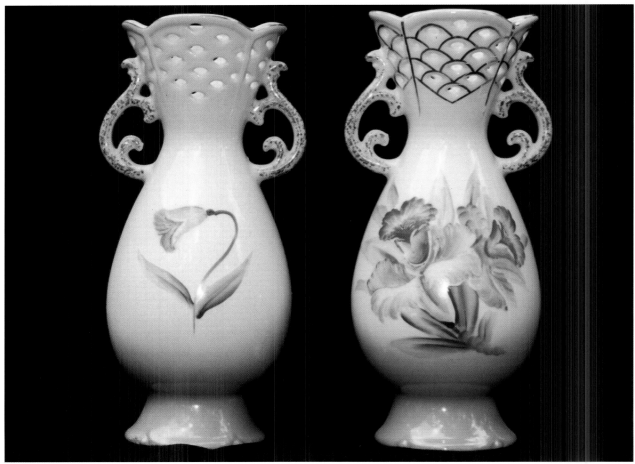

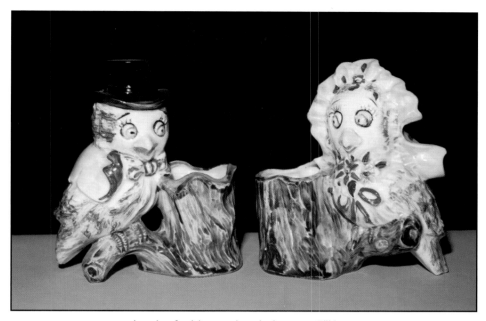

A pair of wide-eyed owl planters. 6"H.
Black MIOJ. *Travis Collection.* $40-50 pair.

An assortment of the more ordinary planters that
are found by collectors. They range from 3"H to
6.75"H. Marked MIOJ. *Travis Collection.* $12.50-20.

Another collection of planters, many featuring
animals. They range in size from 4.5" in width
to 8.875". Most marked MIOJ and others with
Mark #112 horseshoe. *Travis Collection.*
$12.50-15 each.

SALT & PEPPERS AND CONDIMENT SETS

Some of the more desirable salt and peppers are the three piece sets. Sometimes original markings "Japan" are found on the shakers and the trays that hold them are marked "Made in Occupied Japan." This method of marking is customary since it was virtually impossible to stamp all the required words on very small surfaces. These pieces include a wide range of subjects and Occupied Japan collectors compete with salt & pepper collectors for them.

Some of the condiment sets are whimsical, to say the least. The bartender is an unlikely candidate for dispensing mustard, and the dog set has a removal tray where the spoon shows.

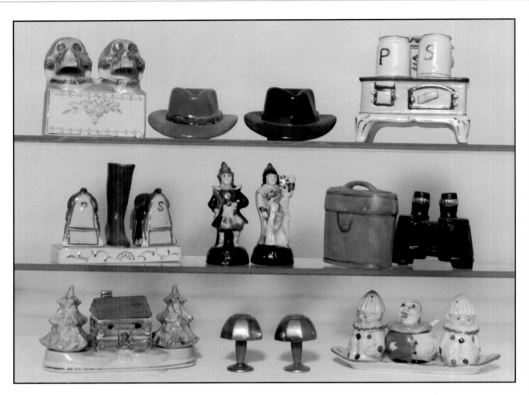

Above: An assortment of salt and pepper shakers with various marks. *Michalek Collection.* $17.50-40.
Right: 4.125"H black chef shakers. The man is marked with a black MIOJ and the woman with a red MIOJ. *Travis Collection.* $45-50 set.

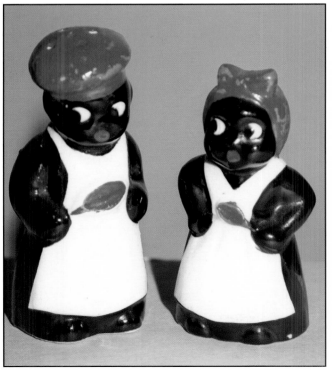

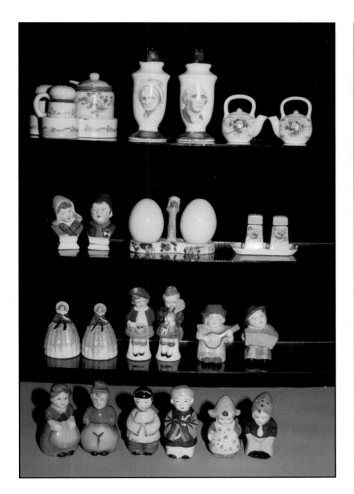

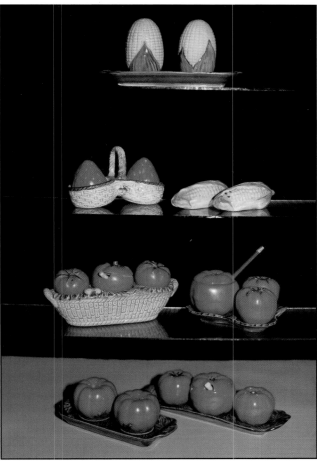

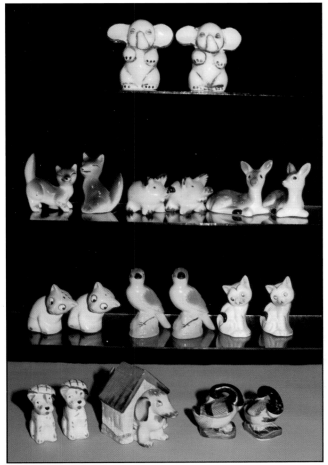

Above left: A dozen sets of salts and peppers. *Travis Collection.* Three-piece sets $17.50-20. Two-piece sets $15-17.50.

Above right: Corn and tomato salt and pepper shakers. *Travis Collection.* The three-piece sets $17.50-20. Others $25-30.

Left: These shakers all represent birds and animals. *Travis Collection.* $15-17.50 each. Dog in the doghouse $20-25.

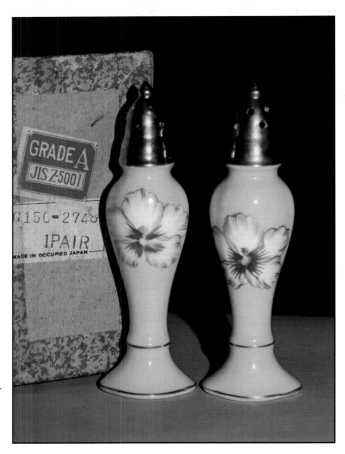

A nice pair of flow-ered shakers with their original box. 5.375"H with a red MIOJ. *Travis Collection.* $35-40.

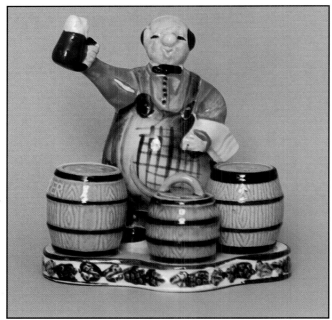

Bartender condiment set with salt, pepper, and mustard pot. 5.5"H x 5"W x 3" deep. MIOJ. *Lushinsky Collection.* $35-40.

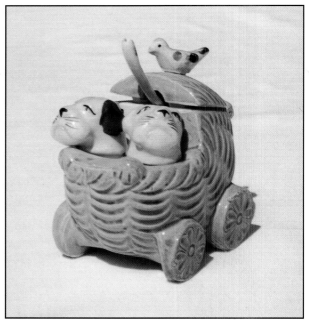

Baby carriage and dog condiment set with a removal insert. 4"H. Black MIOJ. *Gardner Collection.* $45-50.

KITCHENWARES

Items for the kitchen are found in great variety. The aluminum tea container is a great find. Food items were purchased for consumption and the packaging was thrown out in the garbage, consequently an intact Occupied Japan food package today is a rarity. An unopened can of Bamboo Shoots sold on an Internet auction in the winter of 1999 for $66. I wonder where that was found?

Matching canisters and kitchenwares are common, but it is rare to find complete canister sets. The thermos bottle has been found in several colors. Many wooden packing boxes remain, including those for sets of china. One way to display these large pieces is to use them in your room decoration. For example, a wooden packing box can serve as a useful magazine holder in the living room.

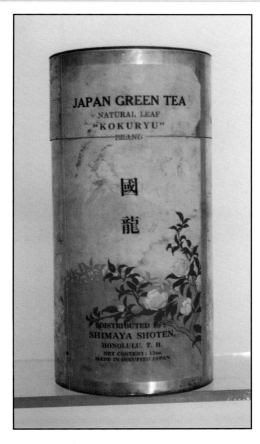

JAPAN GREEN TEA
NATURAL LEAF
"KOKURYU"
BRAND

國
龍

DISTRIBUTED BY
SHIMAYA SHOTEN,
HONOLULU, T. H.
NET CONTENT: 12oz.
MADE IN OCCUPIED JAPAN

Left: A 7.25"H aluminum tea container once contained green tea. Marked Made in Occupied Japan on bottom of label. *Michalek Collection.* $75-85.

Below: A colorful corn platter with individual plates. Platter is 8.5" x 11.5" and the plates are 4.25" x 9.125. Black MIOJ. *Travis Collection.* Platter with four plates $45-55.

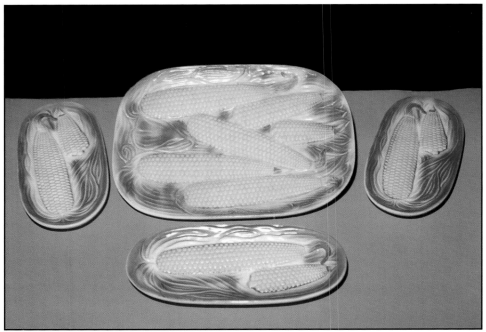

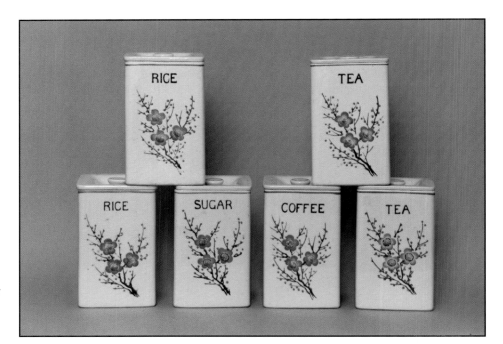

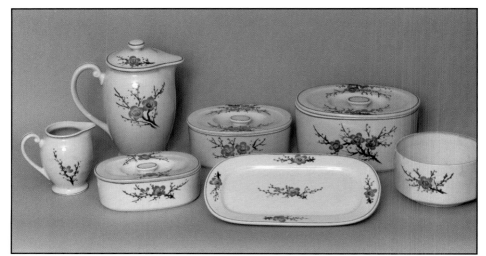

Top: These 7"H canister sets have different markings. Some are marked S.G.K. MIOJ, others are marked S.G.K. Moriyama Allied Forces, and the rest are marked S.G.K. Japan Moriyama but they all match. *Lushinsky Collection.* $25-30 each.

Center: This mixture of serving and storage pieces match the canister set. Most have mark #81 S.G.K. *Lushinsky Collection.* $225-250 for all.

Bottom: This cottage set is missing the tray for the sugar and creamer. Additional pieces include egg cups and a cigarette box with two ashtrays. *Michalek Collection.* $225-250 set as pictured.

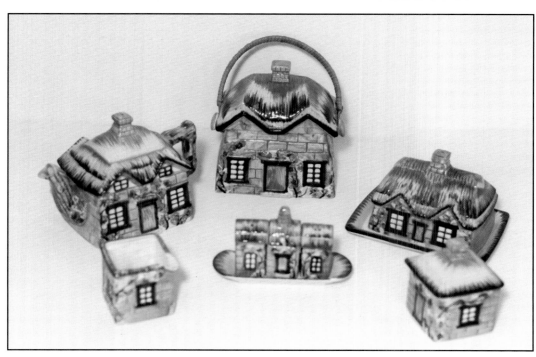

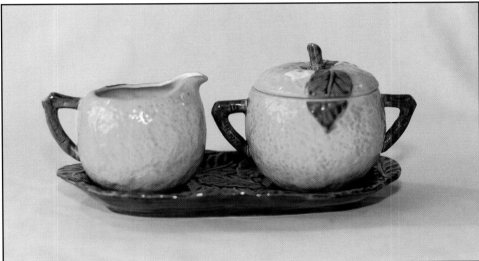

Top: This large pasta bowl measures 14" wide by 3" deep. Mark similar to #164 except printed in red with Handpainted. *Travis Collection.* $30-35.

Center: A citrus set with an orange sugar bowl and a lemon creamer on a tray. 4.25"H. Mark #50. *Svenson Collection.* $35-40.

Bottom: Sun thermos with vacuum bottle. Label marked MIOJ and box stamped MIOJ in ink. Manufactured by Japan Artistic Glass Co. 9.75"H. *Gardner Collection.* $45-50.

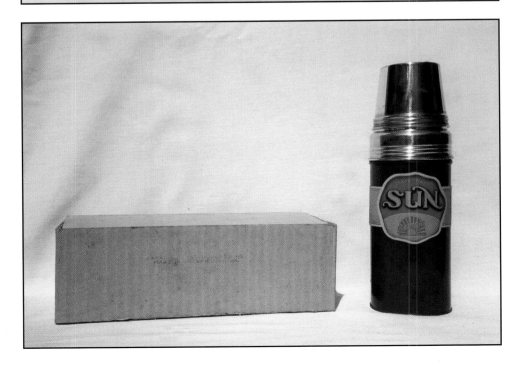

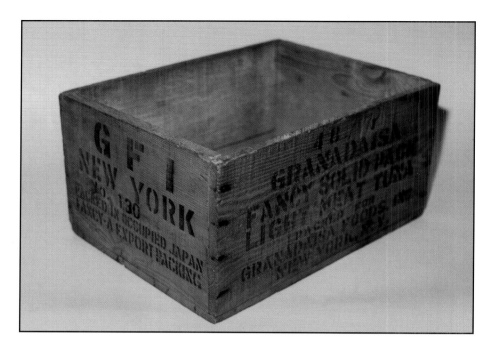

Top: A wooden Tuna packing box. 8"H x 15.25" W x 11.5" deep. Both ends say Packed in Occupied Japan. *Travis Collection.* $100-125.

Center: This shipping crate contained 4 Doz. 6.5 Oz. cans of crabmeat. 8.5"H x 15.5" W x 11" deep. Marked Product of Occupied Japan. *Lushinsky Collection.* $100-125.

Bottom: Another tuna crate is the same size as the crabmeat crate. *Lushinsky Collection.* $100-125

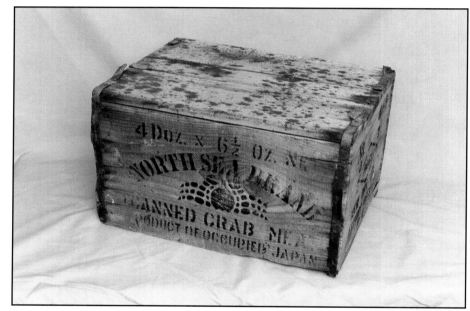

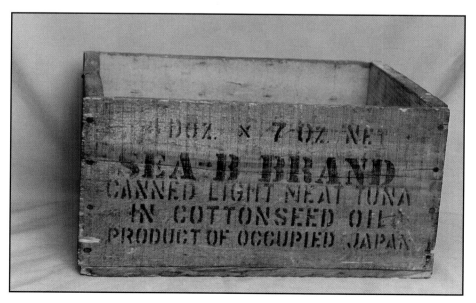

DINNNERWARE & TEA SETS

Complete sets of Occupied Japan dinnerware have been found and as time goes by it becomes apparent that there was a tremendous amount of dishes produced and exported. Some of the patterns have names. Information about the manufacturers is scarce, but Noritake is recognized as one of the biggest producers at the time.

Various serving pieces were made, such as the lovely tiered plate for sandwiches or cake.

Since tea is the beverage of choice in Japan, numerous tea sets were produced for the export markets. The camel set is an especially nice example of the figural pots that are standard in the Japanese trade. Demitasse sets for America were plentiful, and several are illustrated here.

The unusual pair of covered tomato pitchers would be an attractive addition to any collection. The vivid red glaze makes one's mouth water.

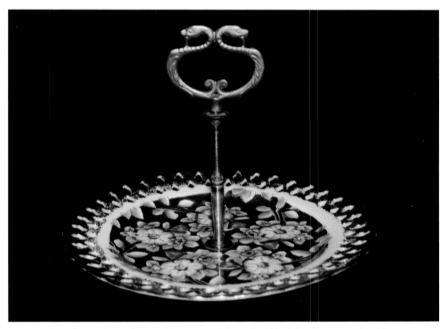

A one-tiered serving plate with a metal handle. Highly decorated with gold accents. Plate is 9" in diameter and the handle measures 7"H. Plate marked Ardalt Japan #6523 and the bottom of the handle is marked MIOJ. *Lange Collection.* $40-45.

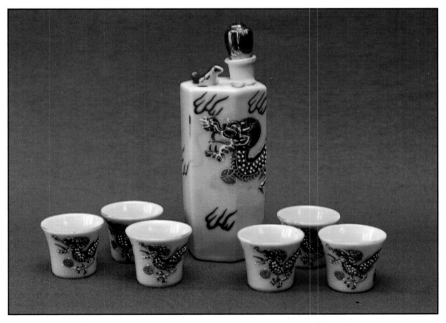

A sake set with the raised dragon pattern. The cups are lithopanes. A Geisha is visible when the bottom is held up to the light. The decanter is 7"H. Red MIOJ. *Ferdinand Collection.* $175-200.

79

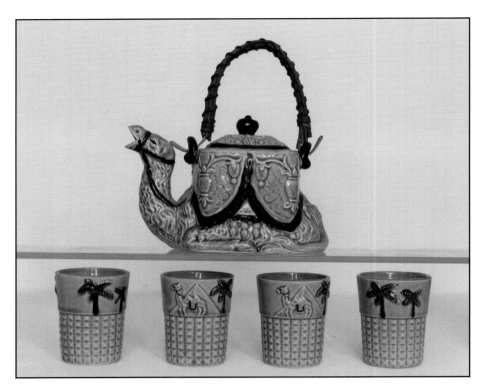

Top: A figural camel tea set. The cups are decorated with Egyptian scenes. The pot is 8.5"H and the cups are 3.5"H. MIOJ. *Michalek Collection.* $75-100 set.

Center: A pretty floral decorated tea set for six. Teapot stands 5"H and the plates are 7.5" in diameter. Gold mark #94 Ucagco. *Seguin Collection.* $200-250.

Bottom: A lovely Oriental raised dragon tea set for six. The pot is 7.5"H. Mark #1. *Aycock Collection.* $250-275.

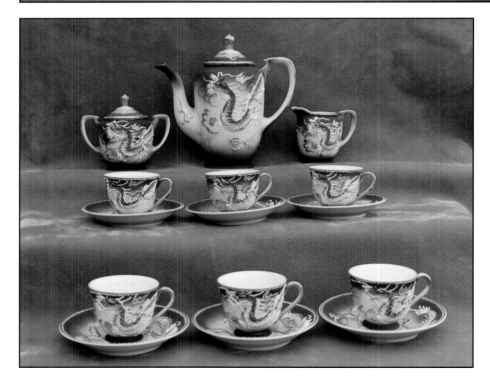

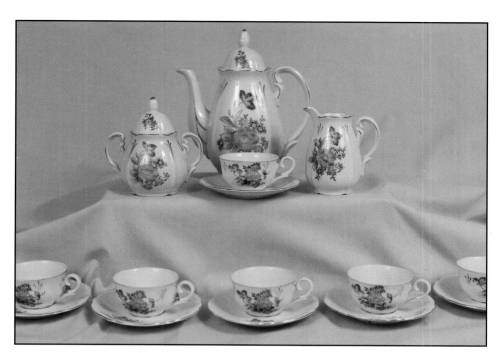

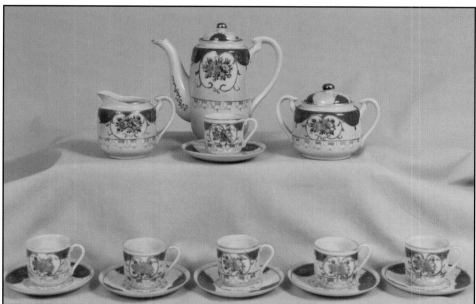

Top: Demitasse set for six with a 8.5"H pot, a sugar and creamer, and cups and saucers decorated with pink and purple flowers. Mark #17 Chugai China. *Straight Collection.* $150-200.

Center: A very ornate demitasse set with a 6.5"H pot, sugar, creamer, and six cups and saucers. Pink and orange flowers with orange highlights and gold trim. Red MIOJ. *Straight Collection.* $150-200.

Bottom: An unusual pair of covered tomato pitchers on a green leaf tray. The large pitcher is 7.25"H and the smaller one is 4.5"H. The tray is 11" long. Mark #50. *Svenson Collection.* $65-75.

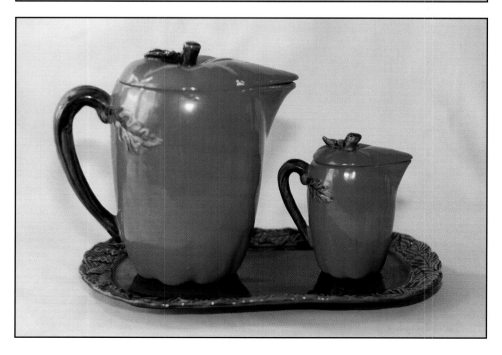

CUPS, MUGS, & TOBIES

As with dinnerware sets, Japanese manufacturers made a variety of cups and saucers that flooded the market. This is a good area to specialize in today, since there are so many to discover. Some of the patterns are elaborate while others are fairly simple, but they all are attractive and make a nice display. The snack set is typical of the styles that were so popular in the early 1950s.

In this group of Occupied Japan collectibles European pieces frequently were copied. The steins shown are faithful copies of German styles. Other mugs have shapes which are enhanced with figural handles that vary from cowboys and hillbillies to different animals.

Toby and character mugs were fashioned in Japan after Royal Doulton originals. Today, there is some confusion between a Toby mug and a character mug. A character mug shows just the head and shoulders, while a Toby mug has a full figure that usually is seated. Now you know.

Above: A very pretty snack set. The plate is 7.75"W. Mark similar to #24 elephant. *Travis Collection.* $20-25.

Right: A collection of demitasse cups and saucers of varied shapes with assorted marks. *Travis Collection.* $18-20 each.

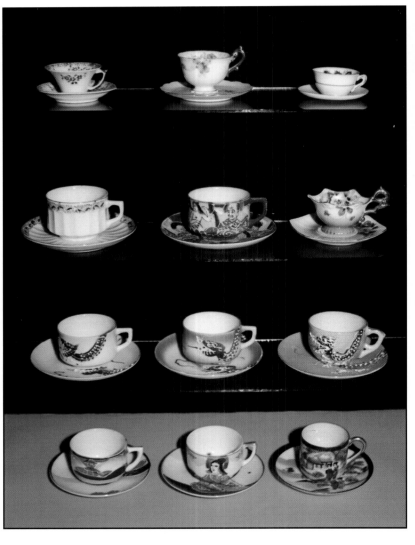

82

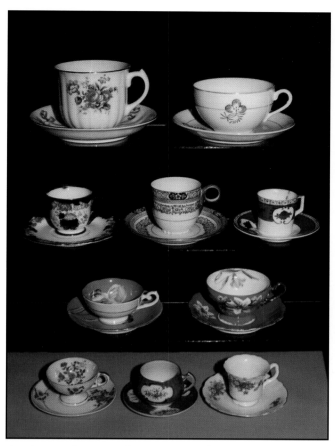

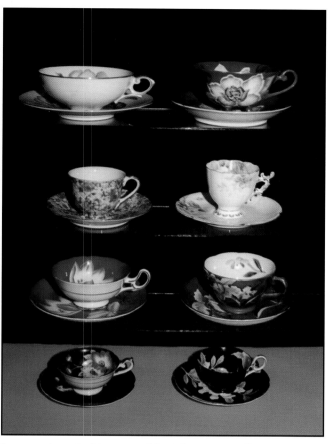

A mixture of cups and saucers with floral decorations. *Travis Collection.* Teacups $20-25. Demitasse cups $18-20.

An assortment of teacups. Most feature an all over pattern. *Travis Collection.* $30-35.

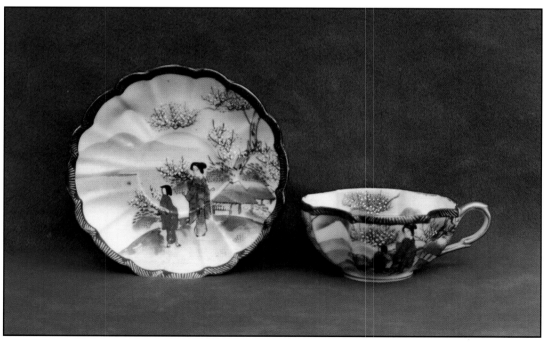

A very Oriental decorated cup and saucer with the Geisha Girl pattern. Mark #8 Lenwile China Ardalt. *Aycock Collection.* $30-35.

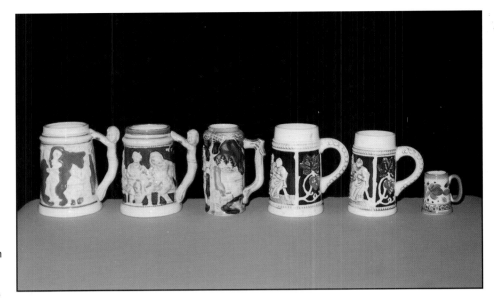

Top: An array of steins ranging in size from 2.375"H to 5.5"H. Numbers 4 and 5 with mark #45 M over G. The rest marked MIOJ. *Travis Collection*. Numbers 1 through 4 $20-25.
Number 5 $18-20.
Number 6 $8-10.

Center: Four large mugs with scenes of people engaged in various activities. Left to right: A mug decorated with four deer, three dogs, a man, and a woman. 8.5"H. Black MIOJ. $40-45. Second mug illustrated with two log cabin scenes and two men, a woman, and a dog. 6.5"H. Mark #45 M over G. $30-35.
The third mug shows two men and a woman seated at a table. 6.25"H. Black MIOJ. $30-35.
The last mug has three men involved in a card game. 6"H. Black MIOJ. *Travis Collection*. $30-35.

Bottom: Two mugs sporting cowboys for their handles. The right cowboy is prepared for a robbery. 5.5" H. *Travis Collection*. $20-25.

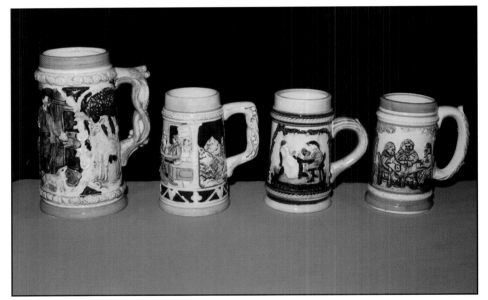

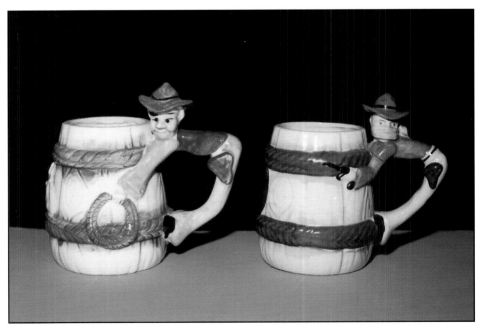

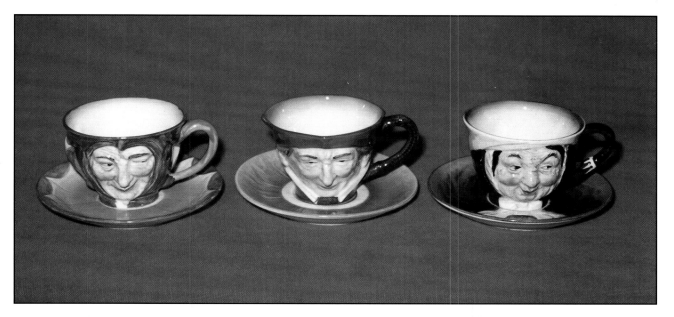

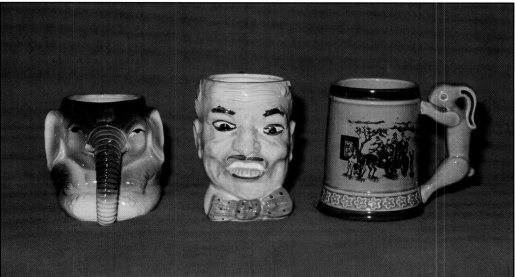

Top: Three cups with blown out faces. Left to right: The Jester, The Englishman, and The Lady. 3" x 5.75". Mark #88 T in a circle. *Agnew Collection.* $35-45.

Center: Left: An elephant mug done in gray and white with his trunk down. Has unusual pink ears. A large green frog can be seen seated inside of this mug. MIOJ embossed on the bottom. 4.5"H. $40-45. Middle: A character mug featuring an ugly man with buckteeth. Has a green parrot handle. 5" h. $35-40. Right: A highly glazed mug with a rabbit handle. 4.75"H. *Agnew Collection.* $40-45.

Bottom: Left: A character mug of a man with glasses. Has a squirrel handle. 5"H. Black MIOJ. $35-45. Middle: A Toby professor carrying books. 4.75"H Red MIOJ. $45-50. Right: A character mug of a man wearing a top hat and sporting a pink bow tie. 4.75"H. Black MIOJ. *Author's Collection.* $35-45.

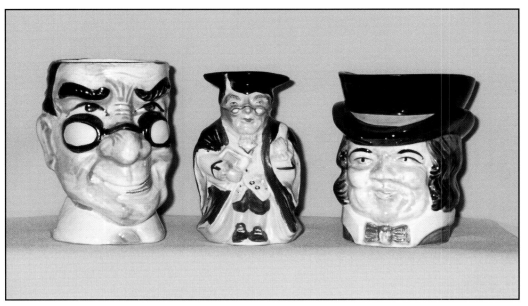

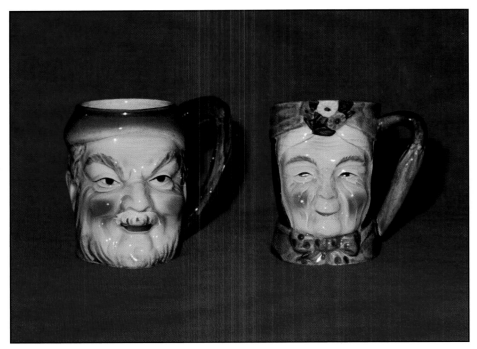

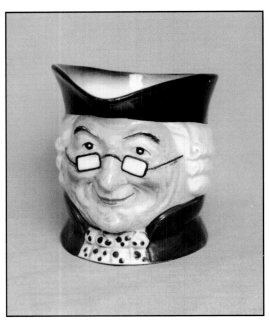

A pair of grandfather and grandmother mugs with umbrella handles. 4"H. *Agnew Collection.* $35-45.

A character mug wearing Ben Franklin glasses. 5"H. MIOJ. *Lushinsky Collection.* $35-45.

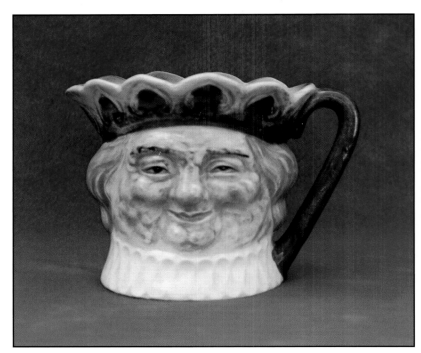

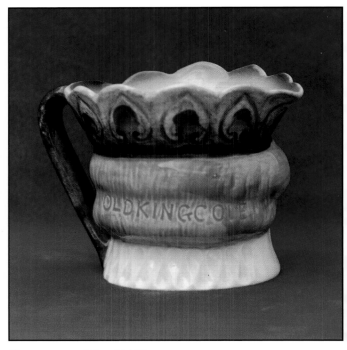

This Old King Cole character mug has its name embossed on the back. 3.5"H. Mark #88 T in a circle. *Aycock Collection.* $50-55.

The reverse of the Old King Cole character mug.

SMOKING ACCESSORIES

Today, since it has been determined that smoking is detrimental to our health, the many ashtrays and other accessories for smoking that was available in the 1950s has subsided from the current marketplace. But this area of Occupied Japan collectibles contains a large variety of items to seek. There are common ashtrays, cigarette boxes, and lighters as well as neat inlaid wooden boxes that automatically hand you a cigarette. Many of the designs are amusing.

The Wedgwood style set shows a fine quality of workmanship that is unusual as some Wedgwood copies were poorly done, but this set is a jewel.

The black nodder ashtray will appeal to black memorabilia collectors as well as Occupied Japan collectors, and the fish ashtray will also appeal to fish collectors. One sometimes has to fight off competition in the hunt for Occupied Japan goods.

A quality copy of Wedgwood is illustrated in this smoking set composed of a cigarette holder and four ashtrays. The holder is 4.25"H and the ashtrays measure 2.75" square. Blue MIOJ. *Travis Collection.* $40-50.

This brown highly glazed set of ashtrays is adorned with Scottie dogs. The holder is 4.25" at its widest point. Embossed MIOJ. *Travis Collection.* $35-40.

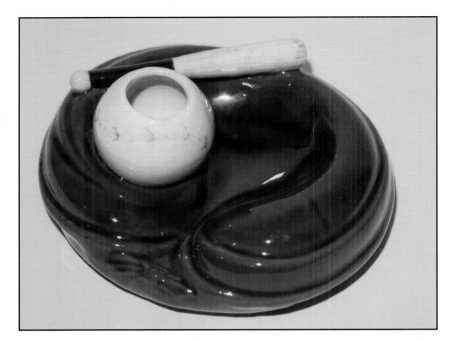

Top: Brown baseball glove ashtray contains a bat and ball. 2.5" x 5" x 5.5". Mark #89 T over M. *Travis Collection.* $25-30.

Center: All marked Chikusa.
Left: Covered swan box. 5"H. $35-45.
Middle: A swan decorated cigarette box. 5" x 4" x 2.5". $25-35.
Right: Candle holder swan. 4"H. *Ferdinand Collection.* $12.50-15.

Bottom: A rather grotesque black nodder ashtray made of lead. 4.625"H x 4.25" W. Marked with a diamond MIOJ DGPAT No. 5169. *Travis Collection.* $45-50.

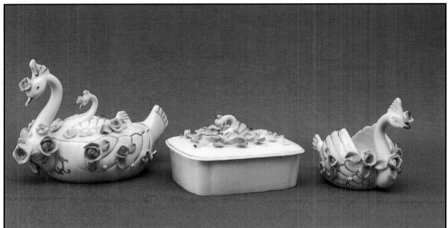

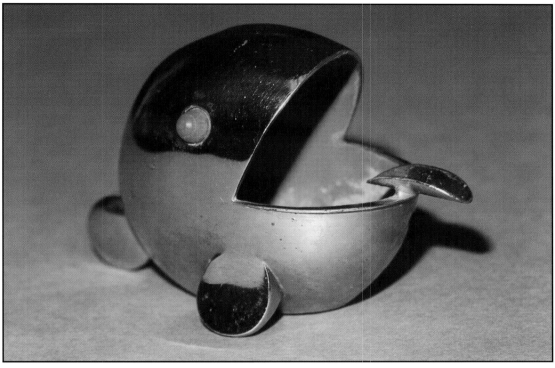

A cute metal fish ashtray with a red interior and a red eye.
3.25"H x 4.75"W. Incised MIOJ. *Travis Collection.* $25-30.

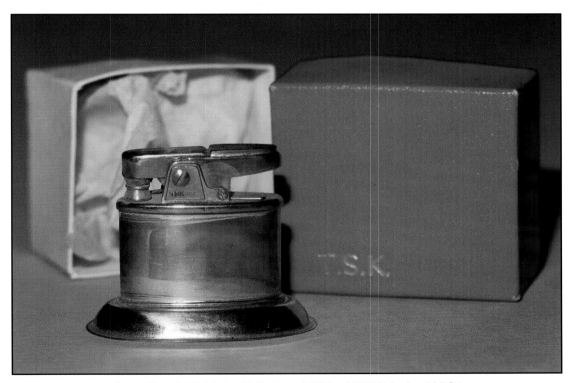

A small metal lighter with its box. 1.5"H x 1.75"W. Incised MIOJ
on the bottom. TSK on the top. *Travis Collection.* $20-25.

BASKETS

Occupied Japan baskets are harder to find than ceramic pieces because many originally were marked with paper stickers that have been lost, and because their construction makes them vulnerable to the ravages of time. A few are found stamped on the bottom with the "Made in Occupied Japan" magical words. These baskets originally were made to be functional and today can still be used for bread, sewing, picnics, purses, flowers, and many styles of decoration.

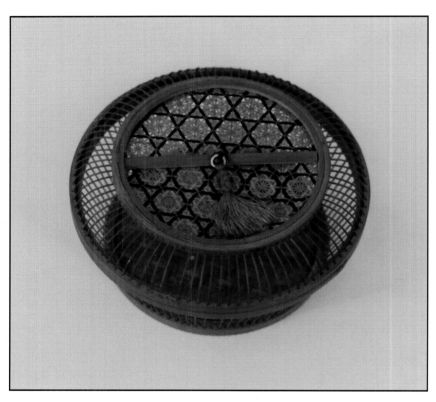

Top: A lovely covered bamboo basket. 7" in diameter and 3.5" H. MIOJ. *Michalek Collection.* $35-40.

Bottom: A set of four nested baskets. 11", 9.625", 8.125", 7.125" diameter. Stamped MIOJ on the bottom of each. *Bolbat Collection.* $70-75 set.

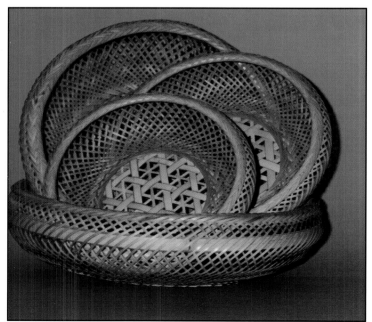

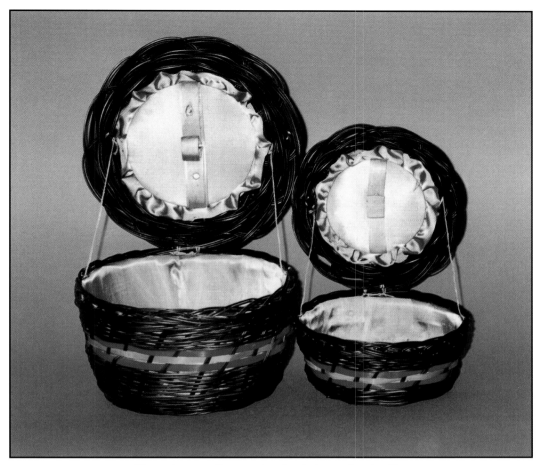

These two nesting sewing baskets are lined with
green satin. 4.5"H x 8.5" W and 2.875"H x 6.5"W.
Paper sticker MIOJ. *Bolbat Collection.* $50-55 set.

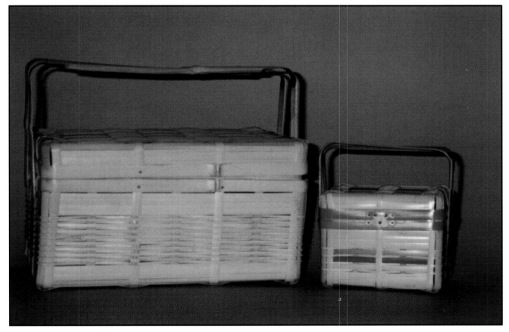

Two double handled blonde baskets. Left: 5.75"H x
10.25" W x 8" deep. MIOJ stamped on bottom. $35-40.
Right: 4" H x 4.75" W x 4.25" deep. MIOJ stamped on
bottom. *Bolbat Collection.* $30-35.

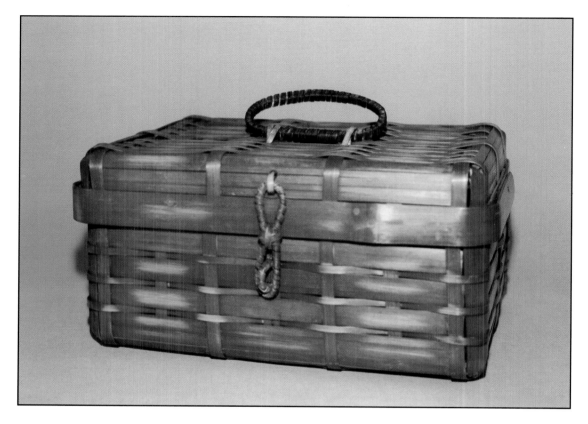

Above: A covered basket with a single handle. 4.5"H x 8.25" W x 6.75" deep. Paper label MIOJ. *Bolbat Collection.* $30-35.

Right: The paper label on the single handled covered basket.

It is not usual for additional areas of interest to emerge within a collectibles field, but over the past couple of years there has been an increased interest in collecting books printed in Occupied Japan. They generally have a bookplate tipped into the back with Japanese writing and the English title, along with the words "Printed in Occupied Japan" followed by a year. Occasionally you will find one that has the words printed on the title page. If a book is marked "Printed in Japan" and is dated during the occupation era, it is considered to be an Occupied Japan collectible.

Many of these books are reprints, from the library of the Japan Travel Bureau, of books that were printed for the English speaking world in the 1930s.

The volumes in the Japan Travel Bureau library feature typical Japanese subjects such as floral art, architecture, ceramics, wood block prints, and many more.

Other books to look for include those published by the United States government for the occupation forces. They include Japanese language books, pocket guides with maps, and cultural guides.

Also, various military unit histories were printed during the occupation and they can be expensive today since military collectors avidly seek them as well. One for the 1st Cavalry Division was valued by a used book dealer for almost $200 because it is a military item. The book verifies that the 1st Cavalry was already in Tokyo to welcome General MacArthur in 1945.

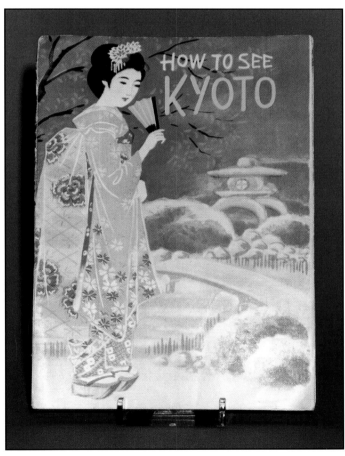

How to See Kyoto, 25 pages. Japan Travel Bureau. 5″ x 7″. Printed in Occupied Japan 1947. *Bolbat Collection.* $10-15.

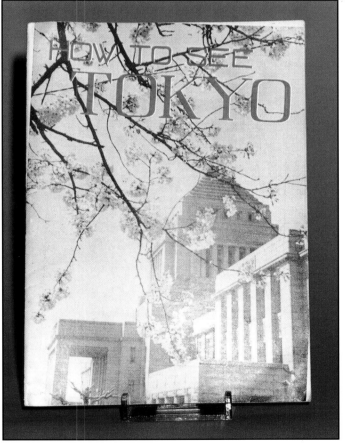

How to See Tokyo, 33 pages. Japan Travel Bureau. 5″ x 7″. Printed in Occupied Japan 1947. *Bolbat Collection.* $10-15.

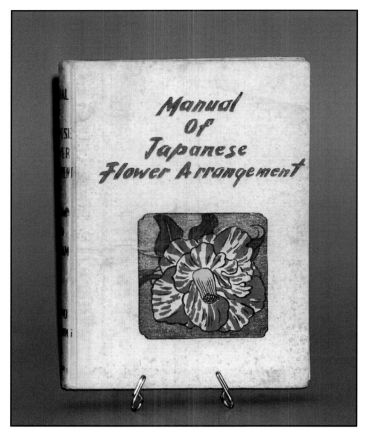

Above: Manual of Japanese Flower Arrangement by Josui Oshikawa and Hazel H. Gorham. Cosmo Publishing Co. Tokyo, 322 pages, Hard cover. Marked with a tipped-in book plate. *Bolbat Collection.* $50-60.

Right: The book plate found in *Manual of Japanese Flower Arrangement*.

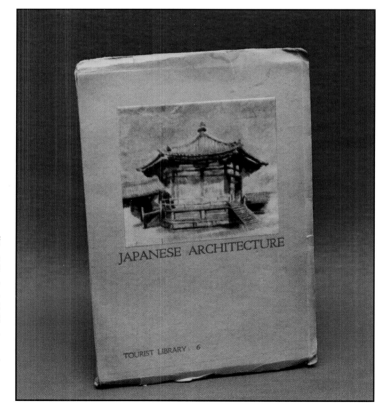

A soft cover edition of *Japanese Architecture*, published by the Japan Travel Bureau, 140 pages. 5" x 7". Marked Printed in Occupied Japan, 1948 on last page. *Ferdinand Collection.* $25-30.

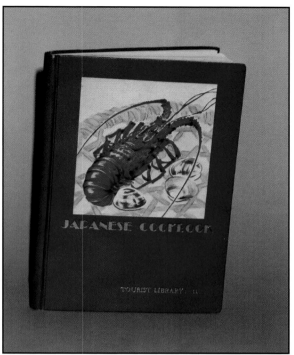

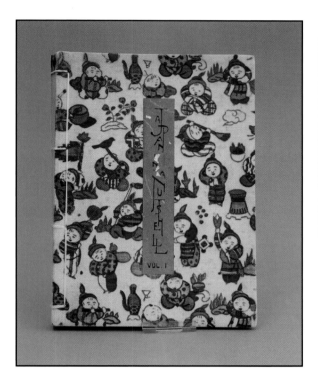

Above: A hard cover edition of *Japanese Cookbook*. Tourist Library 11, 162 pages. Printed in Occupied Japan, 1951. *Bolbat Collection.* $35-40.

Left: *Japan in a Nutshell*, vol. 1 by Atsuharu Sakai. Printed in Yokohama. Copyright 1949. 6" x 8.375". *Bolbat Collection.* $35-40.

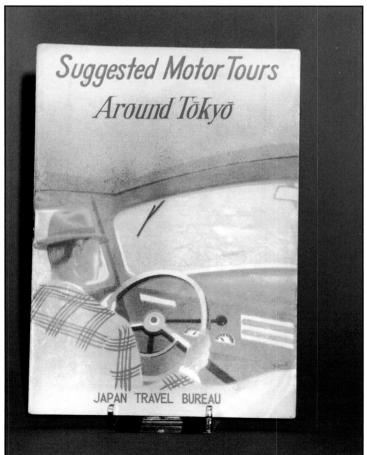

Suggested Motor Tours Around Tokyo published by Japan Travel Bureau, paperback, 32 pages. 5" x 7". Printed in Occupied Japan 1948. *Bolbat Collection.* $10-15.

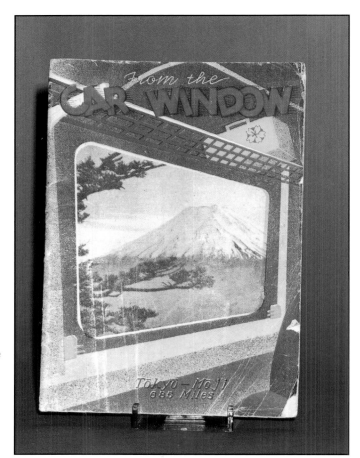

Right: *From the Car Window* by Japan Travel Bureau, paperback, 33 pages. 5" x 7" Printed in Occupied Japan 1948. *Bolbat Collection.* $10-15.

Bottom left: *Kimono* by Keiichi Takasawa, a pictorial story of the kimono. Front cover is autographed by the author in the bottom right hand corner, soft cover, 32 pages. 7.25" x 10.25". *Bolbat Collection.* $45-50.

Bottom right: One of the illustrations from *Kimono*, drawn by the author.

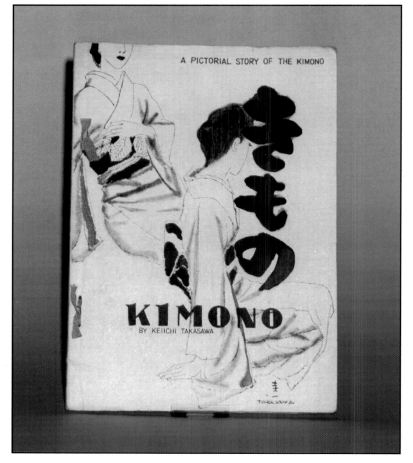

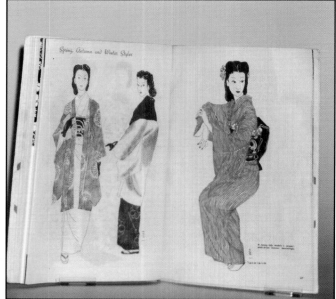

An overabundance of metal souvenir ashtrays were made in Occupied Japan from pot metal. Today, some are in good condition while some are deplorable. Metal boxes also were made in a myriad of styles for common items ranging from cigarettes to jewelry.

Japanese manufacturers produced a great many useful metal objects, such as pencil sharpeners and an array of tools. Kitchen objects include teakettles and vegetable graters. A snow cone ice shaver of Occupied Japan origin is unusual and may be too large to house in one's personal collection, but it demonstrates the widespread variety of metal items that can be found.

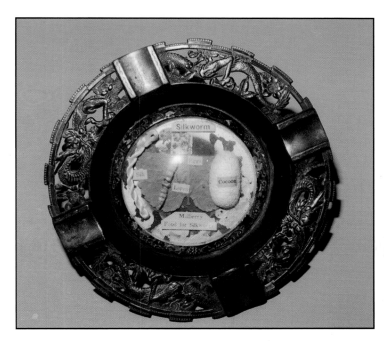

Left: A unusual metal ashtray detailing the life cycle of the silkworm, 5.625" diameter under convex glass. It contains eggs, larva, a cocoon, mulberry food for silk worms and a sample of silk, all labeled. Embossed MIOJ on the bottom. *Travis Collection.* $35-40.

Below: A copper trivet adorned with grapes, fish, and birds. 11" wide. *Lushinsky Collection.* $25-30.

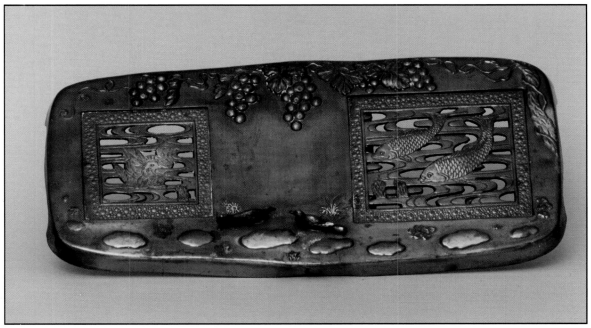

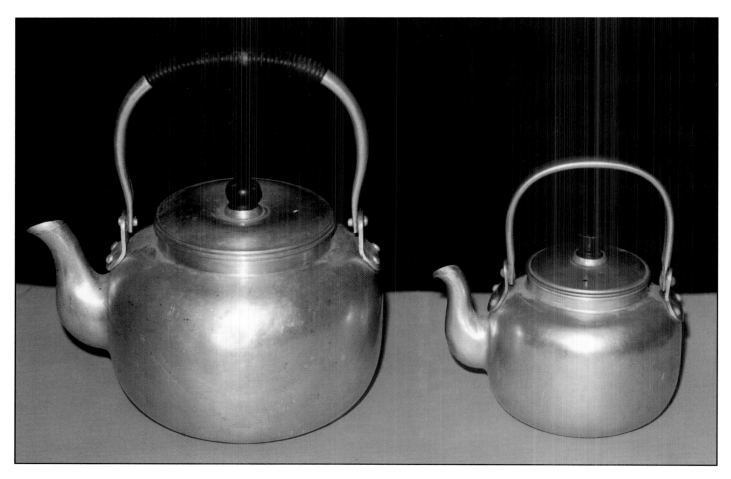

Above: A pair of aluminum tea kettles. Left: 9.5" H to the top of the handle. Holds 60 ounces. Incised MIOJ on bottom with Japanese writing on the handle bracket. $35-40. Right: 7" to the top of the handle. Holds 24 ounces. *Travis Collection.* $20-25.

Right: Double swing hinge with the original box. Extremely heavy. Measures 7". *Lushinsky Collection.* $70-75.

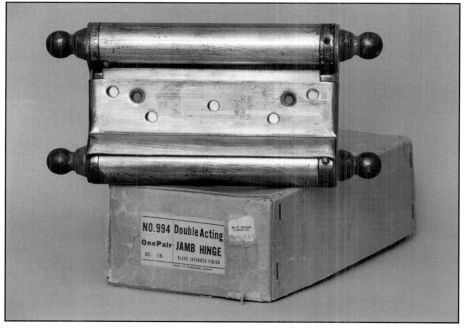

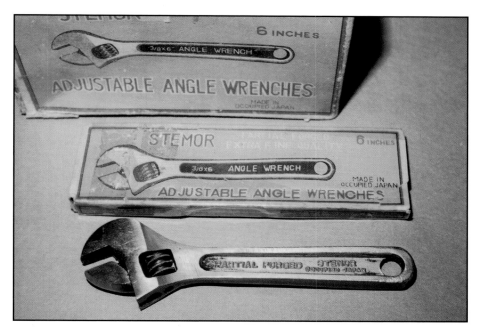

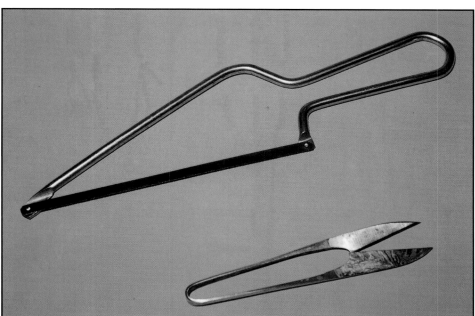

Above: A 6" Stemor adjustable angle wrench with its original box and the box that holds a half dozen of them,. MIOJ printed on boxes and embossed on wrench handles. *Travis Collection.* $35-40 each.

Left: A saw, 10.125" long, and a pair of scissors, 5" long. The owner was told that these scissors were used to repair fishing nets. Both incised MIOJ. *Travis Collection.* $15-20 each.

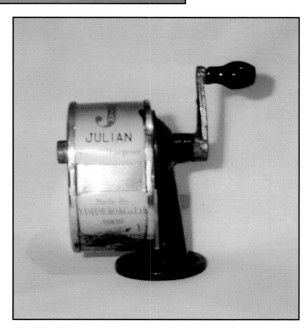

Julian pencil sharpener made by Yamamuro & Co.Ltb. (sic),Tokyo. Also has the following ambiguous instructions printed on it: "Needed by every pencil user everywhere. Sharpens all standard size pencils. Will not break the lead. Place fixed cover case will be altered thrice. MIOJ." All metal except for the celluloid cover. *Gardner Collection.* $40-45.

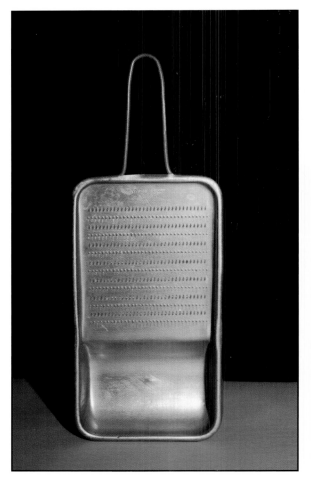

Left: An aluminum grater. 9.25" x 3.5". Incised MIOJ. *Travis Collection.* $15-20.

Below: A box of 100 fish hooks. Note the price of 20 cents! *Travis Collection.* $15-20 for all.

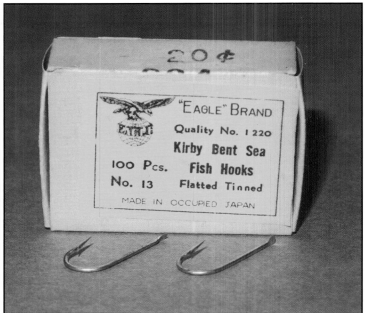

LACQUERWARE

Most of the Occupied Japan lacquerware that is found today is either marked "Imported by Crockery Imports" or has the Maruni back stamp (#51). The bases for these lacquerware pieces can be either wood or metal. A detailed explanation of the manufacture of these pieces can be found in the author's previous book, *Occupied Japan for Collectors* .

Although lacquerware was advertised as alcohol proof and practically indestructible, the original purchasers were apparently reluctant to use lacquered pieces extensively and many are found today in mint condition.

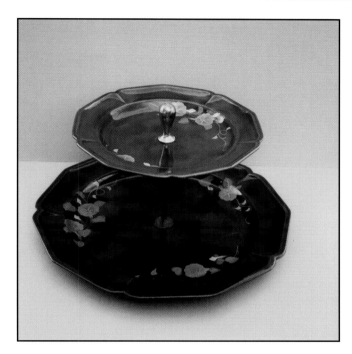

Left: A two-tiered snack tray of metal based lacquerware. 6" high. The top tray is 6.75" in diameter and the bottom measures 9.75". Both trays have Mark #51 Maruni. The bottom nut is also marked MIOJ. *Smith Collection.* $35-40.

Below: A 12" round black serving tray with seven 4.5" H wine glasses. Marked Made by Hand, Occupied Japan, Maruni Lacquerware, and CPO in a diamond. *Straight Collection.* $100-150.

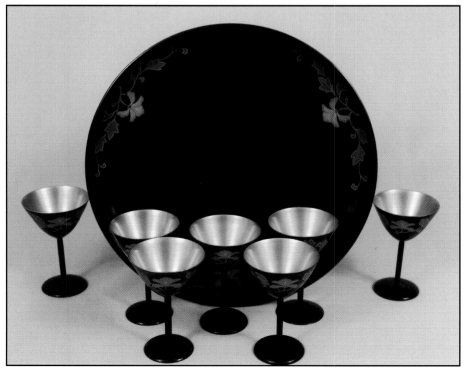

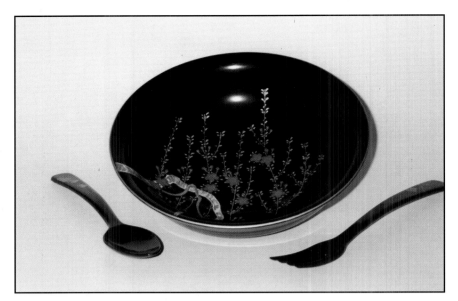

Top: A wooden based lacquerware salad bowl marked by Crockery Imports of Newington, Connecticut. 10" W. The fork and spoon marked Occupied Japan. 10.75" long. *Bolbat Collection.* $60-65 set.

Center: A wooden based lacquerware nut bowl, 5.875"W., and 6 individual small bowls with Crockery Imports mark, 2.5"W. The unmarked spoon is 6.875" long. *Bolbat Collection.* $60-65 set.

Bottom: Three footed bowls, mark #51 Maruni. The larger bowl 7.75"H x 10.5" W. $40-50. Smaller two bowls 5.25"H x 6"W. *Michalek Collection.* $30-35 each.

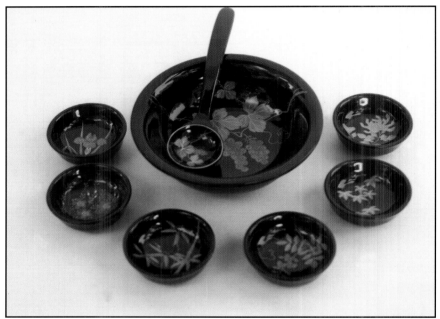

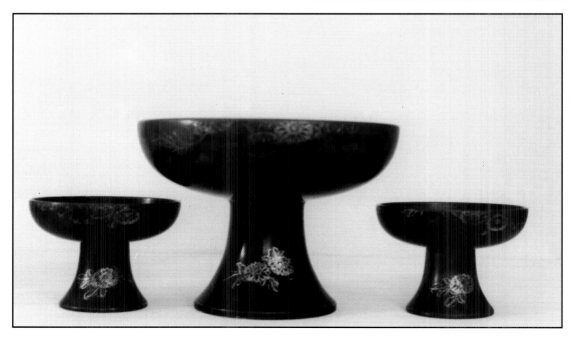

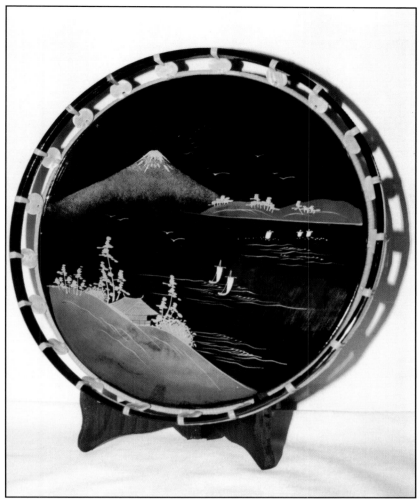

A tray decorated with traditional Japanese scenery. The edges have abalone discs fastened with bamboo twine. 12" diameter. MIOJ. *Lange Collection.* $60-75.

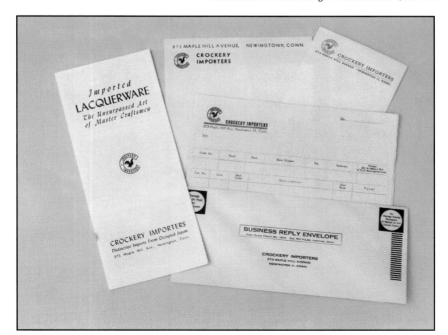

An assortment of stationary, business envelopes, and an order form, as well as the brochure which pictures a number of the lacquerware items available from Crockery Imports of Newington, Connecticut. *Bolbat Collection.*

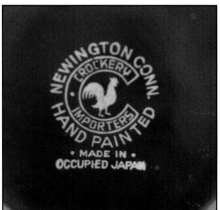

One of several back stamps used by Crockery Imports of Newington, Connecticut.

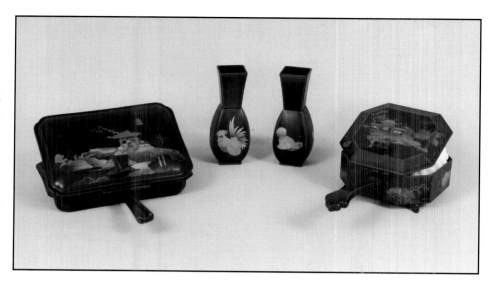

All have Mark #51 Maruni. Left: A silent butler picturing a Japanese house with mother of pearl windows. The box is 8" x 5.625". $50-60. Middle: A pair of 6.25" H vases. One with a rooster and one with a hen. $45-50 pair. Right: Another silent butler rests on four legs. This Japanese home also has mother of pearl windows. 10" x 5.75". *Straight Collection.* $50-60.

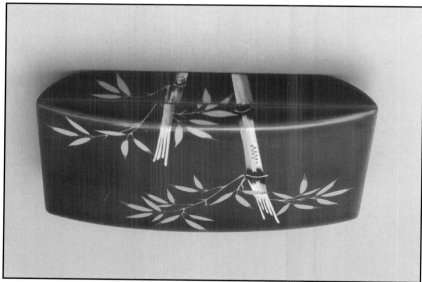

A metal lacquerware bamboo decorated covered box with a beige interior. 1.125"H x 5.5"W x 3" deep. Mark #51. *Bolbat Collection.* $20-25.

A gold decorated black metal lacquerware box measuring 2.25"H x 7.5" W x 5.25" deep. Mark similar to #51 except that middle two lines are missing and instead of Maruni it has Baruni in large script. *Bolbat Collection.* $45-50.

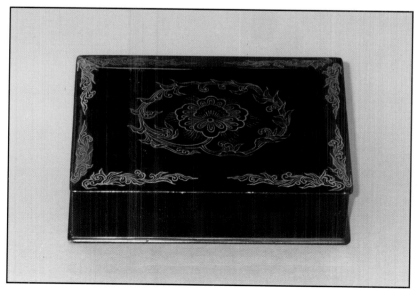

LINENS & RUGS

Occupied Japan table linens are scarce today and those that are found are usually in mint condition and in their original boxes, probably gifts that were never used. Most table linens originally had gummed labels which would have become lost if the linens were used or when they were laundered.

Today there seems to be a good supply of Occupied Japan rugs available. Smaller ones are more collectible than room-sized ones; the larger ones are difficult to display unless you want to use them on your floors. Floor-sized rugs usually show some wear, since they often were heavily used. Some the tags on rugs make interesting reading.

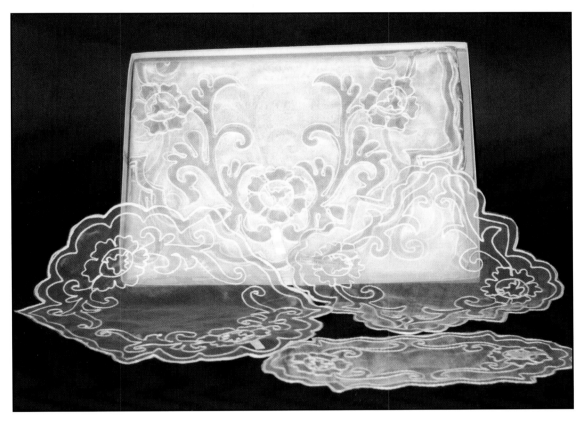

Above: A light blue boxed six-piece doily set decorated with a white pure silk chain stitch. The largest piece measures 15.5" x 40.5". The smallest 9.5" x 10". Each piece has a paper label that says "Pure Silk MIOJ." *Bolbat Collection.* $75-85 set.

Right: One of the labels found on some of the Made in Occupied Japan linens.

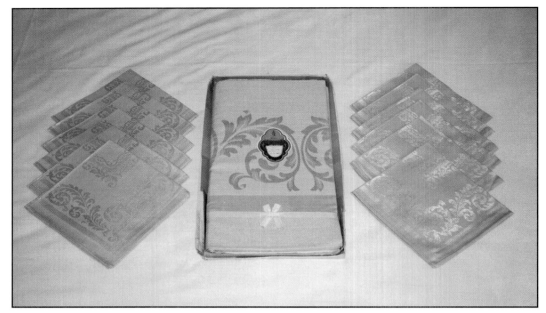

A boxed tablecloth with a dozen napkins. The cloth measures 60" x 102" and the napkins 16" x 16". Marked with a paper label "Real Hadson Cloth Famous for Quality." Each napkin has a label. *Gardner Collection.* $75-80.

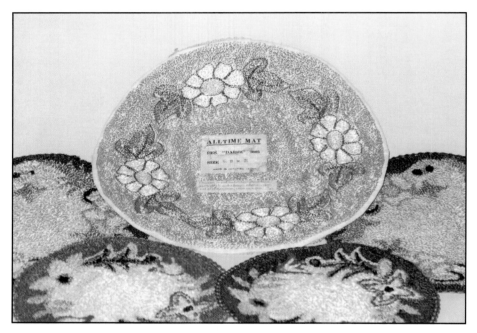

An assortment of hooked mats. The pink one measures 8" and has two labels. The first reads "All Time Mat Des. Daisie 3005 Size 8 x R MIOJ." The paper label reads "Decorative and useful throughout home. Particularly under lamps, ashtrays, vases and as centerpieces, radio tops etc." The two green mats on either side are 6" round and have paper labels. The green and brown mats in the front are 5" in diameter and also have paper labels. *Bolbat Collection.* $18-20 each.

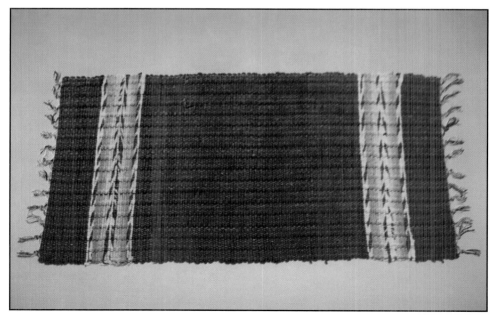

A fringed throw rug measures 18" x 36" and is marked Franklin Rug. *Travis Collection.* $45-50.

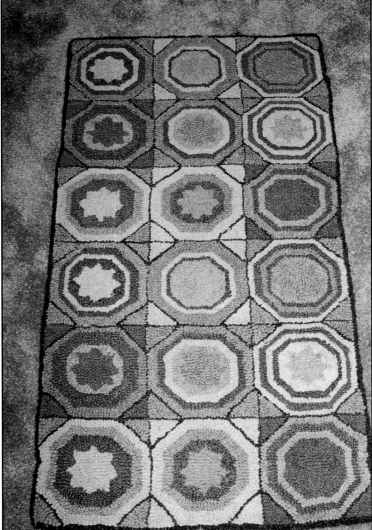

Above: Throw rug with straight edges measures 18" x 36". This one is made by Glendale Rug. *Travis Collection.* $45-50.

Left: A woolen hooked area rug features a colorful octagonal pattern. 2 feet x 4 feet. *Hearn Collection.* $65.

Below: The label sewn into the corner of the octagonal area rug.

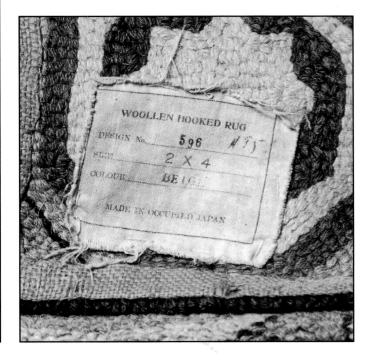

CLOTHING & ACCESSORIES

The large number of clothing and accessory goods made in Occupied Japan covers a wide area. Men's and women's belts and gloves can be found, and this interesting pair of wooden sandals is unusual. Many wonderfully illustrated scarves are found; the majority were imported by Baar and Beard Inc., in their Top Hit Fashion line.

Occupied Japan purses also exist in varieties made of every material imaginable. Several are shown. They were manufactured in many different shapes and for different occasions. It is always prudent to investigate the inside of a purse for the label that says "Made in Occupied Japan."

Jewelry with a confirmed Occupied Japan heritage is a little harder to find since most of it was marked with paper labels that were removed when the wearer first donned them. Finding a complete set in the original box is always exciting!

Accessories for a lady's dressing table were common in the 1950s, ranging from dresser boxes to glass perfume bottles, as shown here. Some bottles were embossed on the bottoms with "MIOJ" (Made In Occupied Japan). One interesting set still sits together on a single tray. Some of the individual bottles found today originally may have come from sets which have been separated and perhaps the tray was broken.

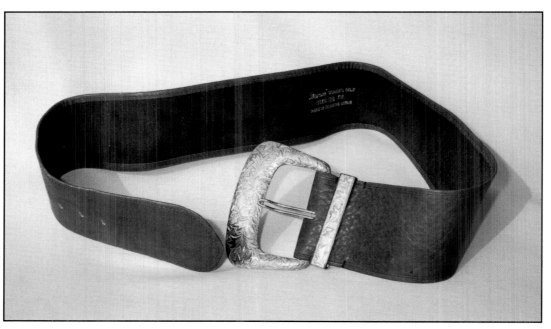

Above: A woman's leather belt. Marked inside "Maruni Women's Belt Size 28 MIOJ." *Gardner Collection.* $40-45.

Right: An unusual silk scarf shaped like a diamond folded in half. The pattern resembles crocheted work. Baar & Beard Inc. label. *Gardner Collection.* $35-40.

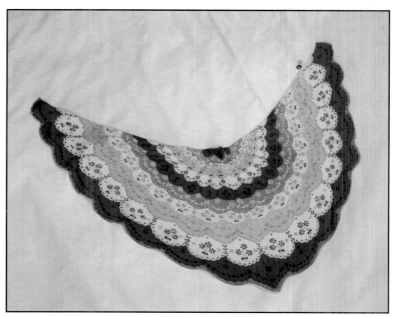

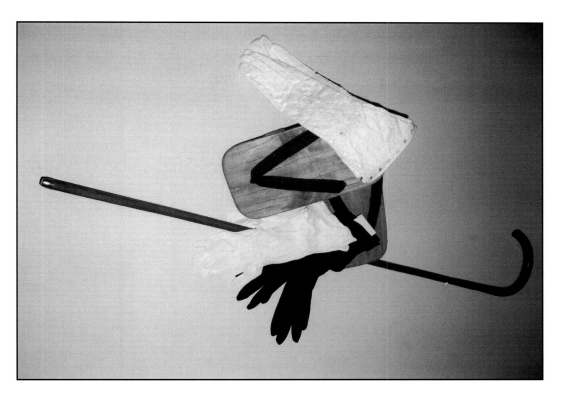

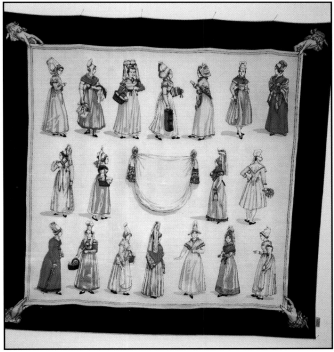

Above: An interesting collection of accessories. Wooden shoes with rocks embedded in the soles. Signed, apparently by the original owner, Jan Long, and marked with a stamped OJ on the bottoms. $45-50.
Gloves of three types: white rayon, black rayon, and white eyelet. Lengths vary from 9.75" to 11.25". They all have cloth labels inside. $10-12 pair.
Wooden cane with a carved handle and metal tip embossed MIOJ. 37" long. *Bomba Collection.* $25-30.

Left: A pure silk scarf featuring women's costumes of long ago and marked with the Top Hit Fashion Baar & Beard, Inc. label. 34" square. *Bolbat Collection.* $35-40.

Below: A hand rolled silk scarf with floral decoration and the Top Hit Fashion label. 33.5" square. *Gardner Collection.* $35-40.

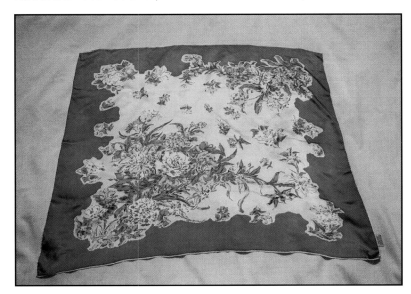

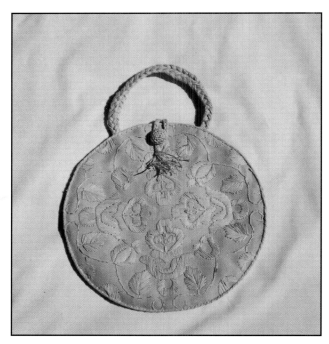

Left: This heavily embroidered fabric purse has straw handles. Label inside. 13" diameter. *Gardner Collection.* $45-50.

Below: This clutch purse has a glued in label "SAGA-NISHIKI HANDICRAFT (see below). Hand-woven Tapestry, Made in Occupied Japan." 7" x 4.75". A cardboard insert in a similar purse gives the <u>origin</u> of the Saga Nishiki Handicraft and tells us that its American representative was Ellen F. Lang of Exeter, Rhode Island. *Gardner Collection.* $35-40.

ORIGIN OF SAGA NISHIKI HANDCRAFT
About four hundred years ago, when Peace was maintained in Japan, "Samurais" had much leisure time. In the province of "Saga" (southern Japan) "Samurais" on duty in the castles, in order to pass these leisure hours designed and originated a type of weaving with a base of lacquered paper and woven with colored silk yarn. Later the wives and daughters of the nobles' families learned this type of weaving as a hobby and have handed down the art to their descendants. It is called "Saga-Nishiki" and has been classed as a nobleman's hobby in Japan.

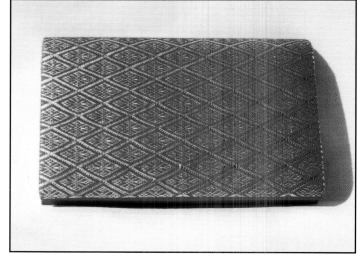

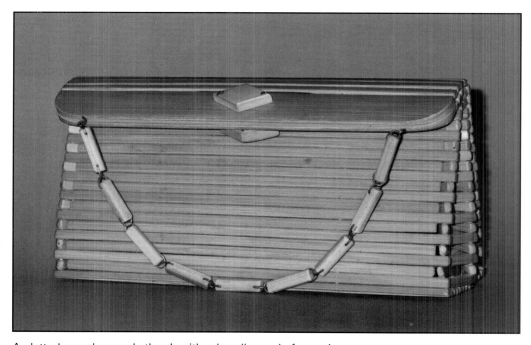

A slatted wooden pocketbook with a handle made from nine 1.25" wooden links connected by metal rings. 7.625" x 11". Stamped MIOJ in black inside. *Bolbat Collection.* $40-45.

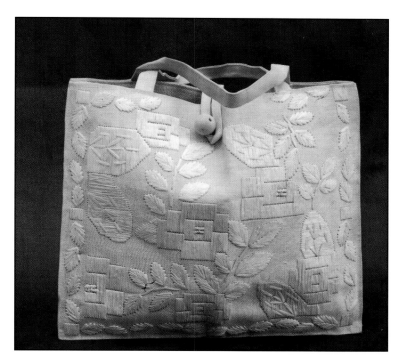

A canvas carryall with a design done in raffia and a wooden ball closure. 12″ x 14″ x 3″. MIOJ tag sewn in. *Bolbat Collection.* $75-85.

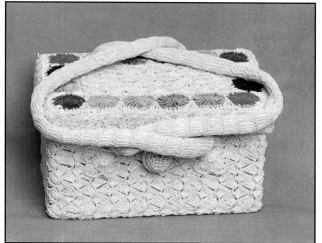

This crochet purse has a cloth tag on the lining of the lid. 5″H and 8″W. *Lushinsky Collection.* $45-50.

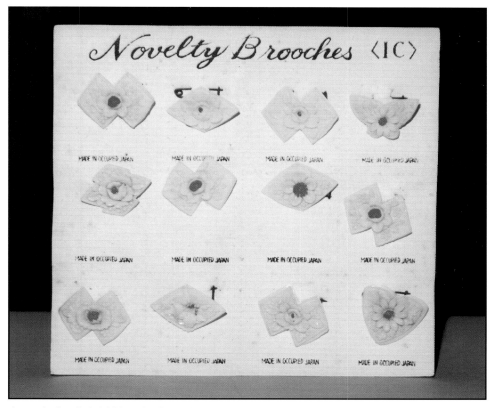

A card of celluloid Novelty Brooches. Each pin is stamped on the back with a purple Occupied Japan. Card 5″ x 5.25″. Pins approximately .75″ wide. *Travis Collection.* $35-40.

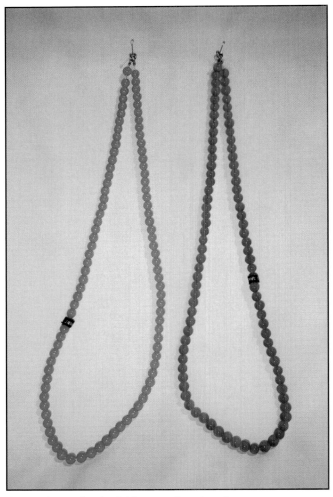

Two strings of colorful heavy glass beads measuring 29.5" long. They are good quality and marked with a paper label. *Gardner Collection.* $25-30 each.

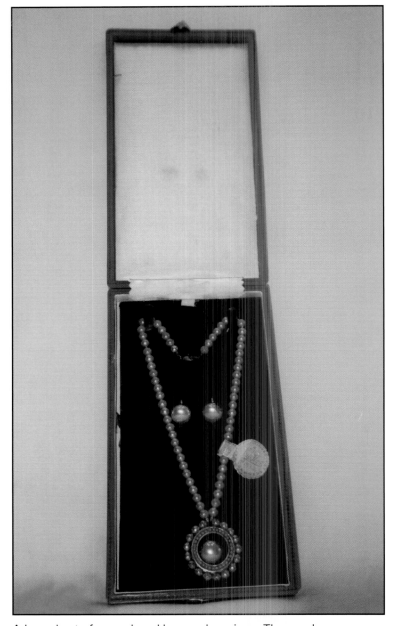

A boxed set of a pearl necklace and earrings. The pearls are 16" long. The label reads "Fuji Pearls, Fujikogeisha" with the MIOJ on the band of the label. *Gardner Collection.* $75-80 set.

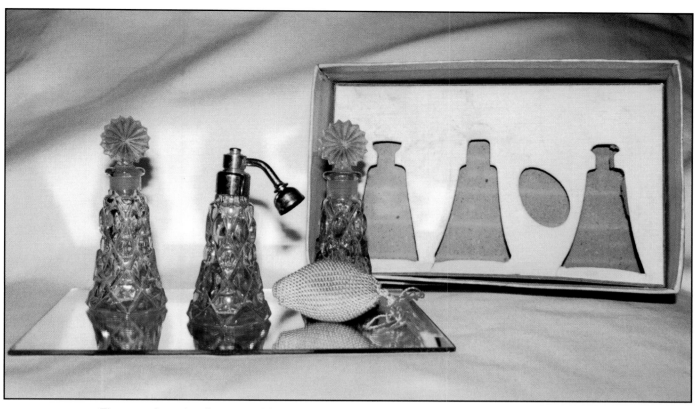

Three perfume bottles, two with daubers and one with an atomizer and the original box.
All pieces are marked MIOJ, including the box and the mirror. *Knighton Collection.* $75-85.

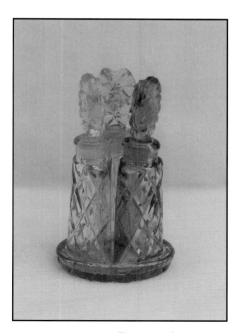
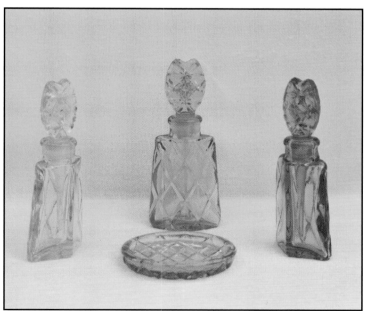

Three perfume bottles, pink, blue and green, fit together on a blue
tray. All embossed with MIOJ. 3"H. *Aycock Collection.* $70-75 the set.

TOYS & DOLLS

Until Chinese and Taiwanese manufacturing of such items began in later years, it is safe to believe that Japanese businessmen were the foremost manufacturers of children's toys in the world. This was certainly true during the occupation of Japan, as well. A wide assortment of toys is marked "Made in Occupied Japan."

The celluloid carnival doll originally was attached to a stick so that a child who was lucky enough to win one, or have someone else win one for him, could carry it around the carnival. More information on Occupied Japan toys is found in Anthony Marsella's book, *Toys from Occupied Japan*.

Above: Elgee Checkers in their original box, 2.5" x 4.75", MIOJ stamped on box. *Bolbat Collection.* $18-22.

Right: Three shuttlecocks in their original tube. The container is 6" x 2.5". Marked MIOJ on label and on the inside of each shuttlecock. *Lushinsky Collection.* $20-25.

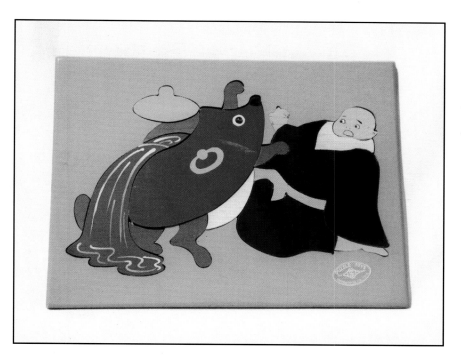

Above: "The Wonderful Teakettle" wooden puzzle. 8.5" x 11". *Gardner Collection.* $35-40.

Left: Three inflatable animal toys. The rabbit is 7.5" x 3.5", the chick 5.75" x 5.25", and the rooster 6" x 7.5". *Michalek Collection.* $35-40 each.

Below: A friction drive motorcycle. 4" x 2". Marked Trade Mark TM in a diamond SHOWA. *Lushinsky Collection.* $250-300.

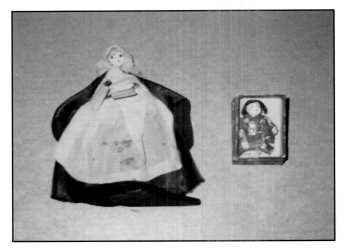

A mechanical rabbit which strums his guitar while his head moves from left to right. 8"H. MIOJ. *Michalek Collection.* $150-200.

Left: A pilgrim doll fashioned from a pipe cleaner, wire, and cloth attached to a wooden platform. 5.75"H. Paper label on platform. $50-60.
Right: A tiny 2"H composition doll marked with a paper label on her dress. *Bomba Collection.* $35-45.

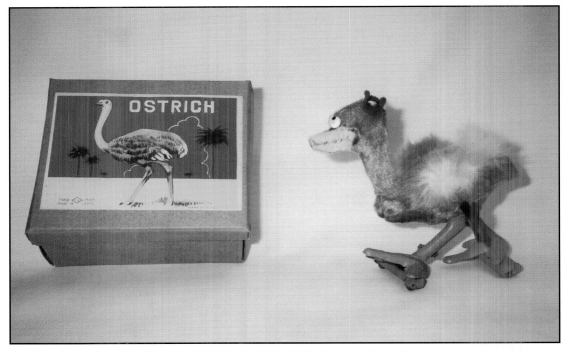

Wind-up ostrich toy with original box. 5.5" x 4.75". MIOJ. *Gardner Collection.* $150-175.

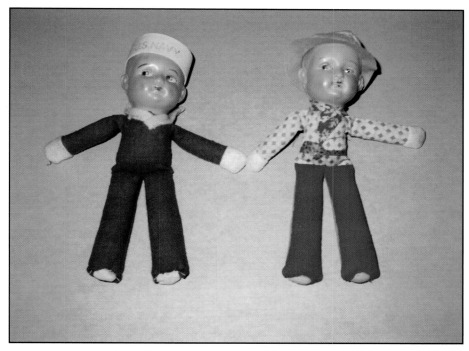

Both celluloid doll heads are from the same mold.
Their cloth bodies are 10" H. Marked MIOJ on
insides of hats. *Bomba Collection.* $50-60 each.

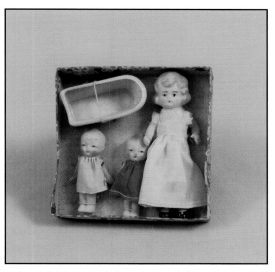

A boxed set containing a porcelain bathtub
and three bisque dolls ranging in size from
2.625" to 4.5". Box has a paper label 6084
MIOJ in purple ink. Also marked SS Kresge
Co. 25 cents. *Straight Collection.* $75-100.

A celluloid carnival doll dressed in pink
feathers. 7"H. *Gardner Collection.* $50-65.

MINIATURES & NOVELTIES

Here is a representation of some of the pieces that come to mind when one hears "Made in Occupied Japan." These are the items that were sold in the dime store.

Some of the novelties produced by the Japanese make one chuckle. The stereotype drunkard man leans against the lamppost, and the saucy monkey wizards stick out their tongues.

Holiday decorations were an important and big part of Japan's production, too. They could be used as ornaments on the Christmas tree, or as table decorations at Halloween, or as candy containers at Easter dinners. Some of the more fragile decorations have survived well because they have been packed away for the better part of each year.

Above: Left to right: 1. Inflatable rubber ball, 7.5" deflated. Marked with the letters "H.R.K." and a black MIOJ. $45-55. 2. Brown rubber lizard, 8" in length, raised mark. $20-25. 3. 8" rubber knife marked with raised MIOJ with "TOHO". $10-15.
4. Papier maché spider has spiraled legs and antennae that readily wiggle when suspended, 2.75" body length, circular paper label. $35-45.
5. Papier maché rabbit also has spiraled legs and arms, 3.25" body with circular paper label. *Bomba Collection.* $25-30.

Left: Pipe cleaner man leaning against a wooden lamppost. 5.625"H. Paper label MIOJ. *Travis Collection.* $12.50-15.

Below: This paper label on the pipe cleaner man was glued on in reverse.

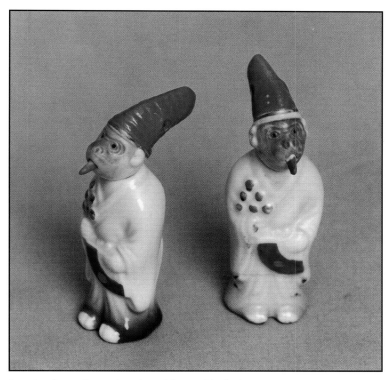

A pair of monkey wizard nodders with their tongues sticking out. 3.5"H. *Lushinsky Collection.* $45-50.

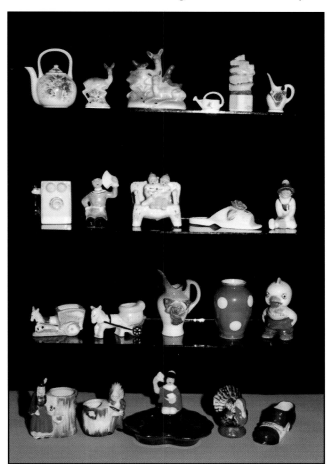

Three Christmas novelties, all with paper labels. The Santa tree ornament is constructed mainly of pipe cleaners. 4.5" H. $40-50.
The stick Santa has a pipe cleaner hat and a cotton beard. 4.625" long. $10-15.
The glass bead Christmas decoration is 3.25" long. *Straight Collection.* $10-12.

A group of miniatures ranging in height from 1.25" to 2.875". Most are marked MIOJ. *Travis Collection.* Ashtray in the bottom row $10-12.50.
Others $5-8 each

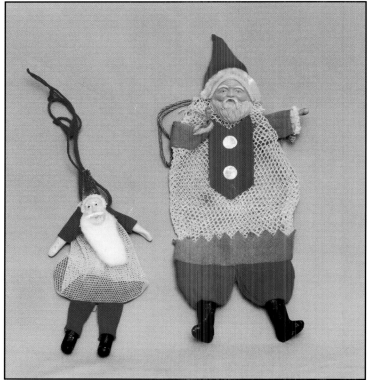

Above: Snow people, all marked MIOJ. Top shelf, 6.5"
to 7.625" H. No 1, $45-50.
No 2 and No 3, $35-40 each.
Bottom shelf: Left: house, 4" H. $50-60.
Middle: snowman, 5"H. $25-30,
Right: house, 3"H. *Michalek Collection.* $20-25.

Left: Two Santa candy containers with celluloid faces,
felt pants and arms, bisque boots, and net bodies.
Both have paper tags. Smaller, 4.5"H. $45-50.
Larger, 7"H. *Lushinsky Collection.* $55-60.

Below: A Santa Claus on skis. 4" x 6". MIOJ paper
label. *Travis Collection.* $50-70.

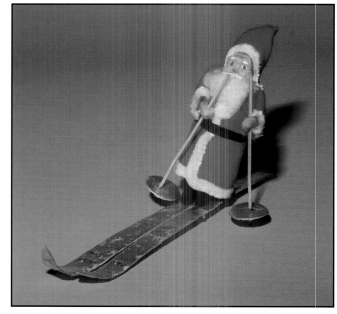

This group encompasses a diverse variety of collectibles and some of them are wonderful and unusual, to say the least. Occupied Japan furniture is not plentiful, but in addition to this folding chair one occasionally can find captain's chairs, wooden kitchen sets, hutches, and lacquerware end tables and coffee tables.

The roll of film is a most unusual Occupied Japan item. Why didn't someone use it long ago? The thermometer is in mint condition. Does it still work accurately? How many dog collars have survived? Collecting Occupied Japan always raises so many questions.

A folding chair with metal frame and wooden seat. The mark is burned into the center of the seat. *Hearn Collection.* $40-45.

Leather dog collar. 19.5" long, incised MIOJ. *Gardner Collection.* $35-40.

Box of six rolls of Mycro Film, 10 exposures each. 2.75" x .875" box stamped MIOJ on the back. *Gardner Collection.* $15-20.

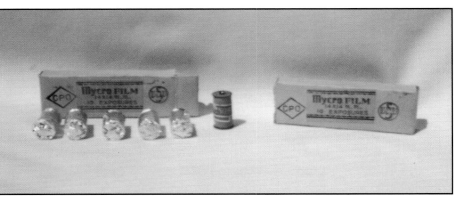

Probable cooking thermometer marked Propper-Made in Occupied Japan. The wooden tube marked with paper label: Propper Thermometer, 0 to 300 F and Range, TESTED AND GUARANTEED FOR ACCURACY, Propper Manufacturing Co., Inc. L.I. City 1, N.Y." 12" long. *Gardner Collection.* $40-45.

Above: Three-section bamboo fishing pole (not a fly rod since there is no place for a reel). It has one small eye on top, line was tied off at the bottom. 10 feet long. Marked with paper label. *Travis Collection.* $50-60.

Right: Child's fishing kit. 2.5" x 3". Stamped upper left with a purple MIOJ. *Travis Collection.* $25-30.

A six-foot wooden folding ruler marked with MIOJ between the 7" and 8" markings. *Travis Collection.* $20-25.

A level with its cardboard box. 18" long. Incised BULLFIGHT MIOJ. *Gardner Collection.* $25-30.

Four wooden cup and plate holders. 2" across. *Lushinsky Collection.* Smaller ones $10-12.50. Larger ones $12.50-15.

Top: One of the many cards of buttons exported to the United States. These are genuine ocean pearl. They are difficult to find intact as they were purchased to be used. *Travis Collection.* $8-10.

Center: A group of patriotic lapel pins. The cards are approximately 1.125" x 1.875". *Travis Collection.* $5-8 each.

Bottom: The graphics on this needle book are representative of those found. Printed MIOJ in the lower right hand corner. 3.5" x 6.5". *Travis Collection.* $8-10.

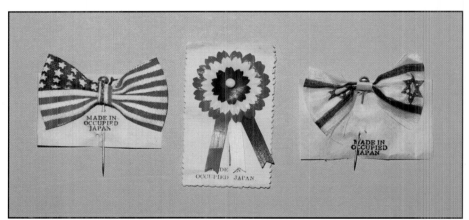

RELATED ITEMS

This is an area that creates a lot of discussion among Occupied Japan collectors. Is a piece that is dated during the occupation, but not marked "Made in Occupied Japan," considered to be an Occupied Japan collectible? During one convention of The Occupied Japan Club, it was decided that this was an individual decision.

The metal paperweight is a wonderful souvenir of the occupation, but was it made in Occupied Japan or in America when the troops ship returned home? The medals were probably cast in the United States, but they still are a great enhancement to a collection of Occupied Japan items. The bedspread, with its date, has the appearance of Japanese silk and undoubtedly was embroidered in Occupied Japan. All of this is relative.

Above: Metal paperweight fashioned from captured Japanese material during the Occupation. 2"x 3". *Travis Collection.* $35-40.

Left: Telephone book for the Greater Tokyo Area, dated during the Occupation. *Ferdinand Collection.* $15-20.

The front of the U.S. Navy Medal of Occupation. The medal is 1.25" in diameter and the ribbon measures 1.375" x 1.25". *Bolbat Collection.* $30-35.

Reverse of the U. S. Navy Occupation medal.

The U. S. Army's Occupation medal. *Bolbat Collection.* $30-35.

Reverse of the U. S. Army Occupation medal.

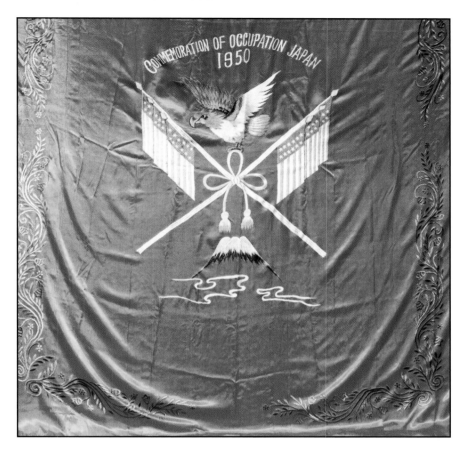

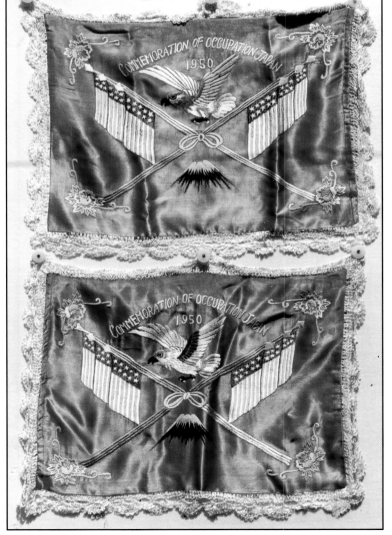

This full-sized silk bedspread and two pillow shams with hand embroidered decoration are souvenirs of the Occupation of Japan, dated 1950. Spread 86" x 102". Shams 29" x 26" *Baker Collection.* Owner value $450.

FAKES & FORGERIES

The subject of fakes and forgeries in Occupied Japan collectibles is more fully treated in the author's previous book, *Occupied Japan for Collectors*. Since writing that volume, many fake Occupied Japan black figurines have appeared in the marketplace. Several of these can be found in the catalog of one of the companies dedicated to reproductions and copies of several categories of collectibles. In addition to those pictured, there is one of a black boy seated on a trunk eating a piece of watermelon. Although the pieces are bisque, the finish on them is somewhat rough and the coloring is much too bright to be a bisque Occupied Japan item. It is very important to know how the authentic item should look and what the marks should be. If in doubt, pass the piece by.

Occasionally a piece is found with a "Made in Occupied Japan" mark stamped on the bottom that can be removed. I tested one of these once (the letters were so perfect I became suspicious) and it rubbed right off with a wet finger. Many collectors adhere to the fingernail polish remover test (if a mark comes off with fingernail polish remover, leave the piece where you find it) and I'm sure that this works on the glazed pieces, but I worry about some of the bisque pieces that may be authentic and end up having their authenticity destroyed.

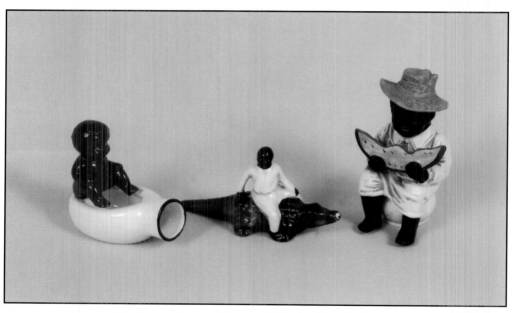

The brown boy on the potty is incised on the bottom Occupied Japan. The other two pieces have the same pink MIOJ stamp. *Straight Collection.*

Hundreds of marks appear on the bottoms of authentic Occupied Japan items, over 200 are presented here. We are indebted to Margaret Bolbat and Frank Travis for many of the photos of newly found marks.

The number of marks recorded has swelled because so many dinnerware sets now have been studied with different marks. Also, some of the potters and importers used several variations of their markings.

1.

2.

3.

4.

5.

6.

7.

8.

9.

10.

11.

12.

13.

14.

15.

16.

17.

18.

19.

20.

21.

22.

23.

24.

25.

26.

27.

28.

29.

30.

31.

32.

33.

34.

35.

36.

37.

38.

39.

40.

41.

42.

43.

44.

45.

46.

47.

48.

49.

50.

51.

52.

53.

54.

55.

56.

57.

58.

59.

60.

61.

62.

63.

64.

65.

66.

67.

68.

69.

70.

71.

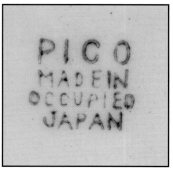

72.

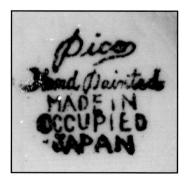

73.

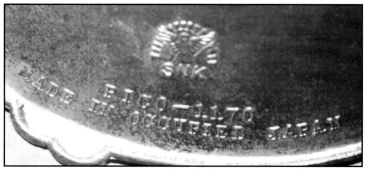

74.

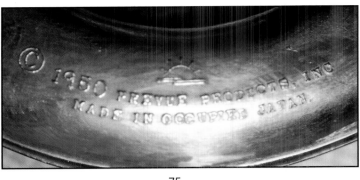

75.

76.

77.

78.

79.

80.

81.

82.

83.

84.

85.

86.

87.

88.

89.

90.

91.

92.

93.

94.

95.

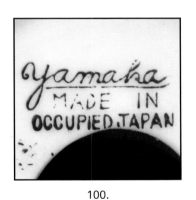

96.

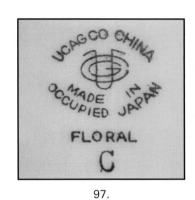

97.

98.

99.

100.

101.

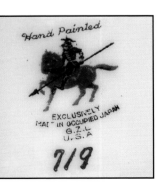

102.

103.

104.

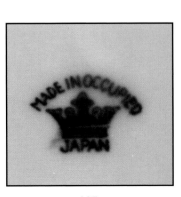

105.

106.

107.

108.

109.

110.

111.

112.

113.

114.

115.

116.

117.

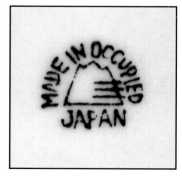

118.

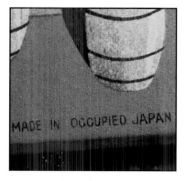

119.

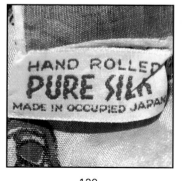

120.

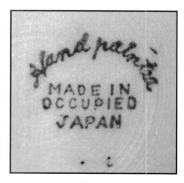

121.

122.

123.

124.

125.

126.

127.

128.

129.

130.

131.

132.

133.

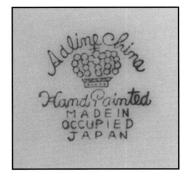

134.

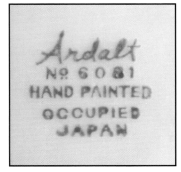

135.

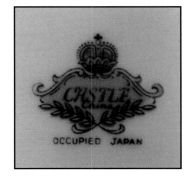

136.

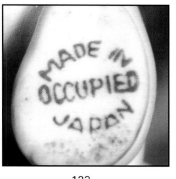

137.

138.

139.

140.

141.

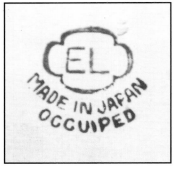

142.

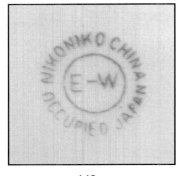

143.

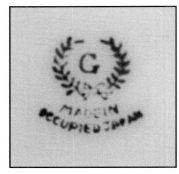

144.

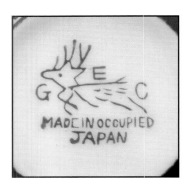

145.

146.

147.

148.

149.

150.

151.

152.

153.

154.

155.

156.

157.

158.

159.

160.

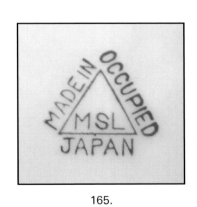

161.

162.

163.

164.

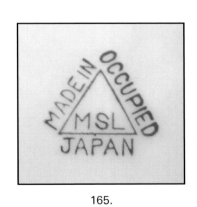

165.

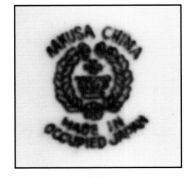

166.

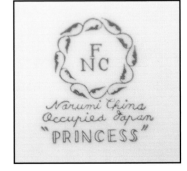

167.

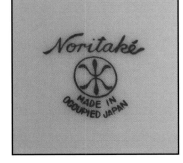

168.

169.

170.

171.

172.

173.

174.

175.

176.

177.

178.

179.

180.

181.

182.

183.

184.

185.

186.

187.

188.

189.

190.

191.

192.

193.

194.

195.

196.

197.

198.

199.

200.

201.

202.

203.

204.

205.

206.

207.

208.

209.

210.

211.

212.

213.

BIBLIOGRAPHY

Florence, Gene. *The Collector's Encyclopedia to Occupied Japan Collectibles. Fifth Series.* Paducah, Kentucky: Collector Books, 1992.

Klamkin, Marian. *Made in Occupied Japan: A Collector's Guide.* New York: Crown Publishers, 1976.

Marsella, Anthony R. *Toys from Occupied Japan.* Atglen, Pennsyslvania: Schiffer Publishing Ltd. 1995.

McCarthy, Ruth. *Lefton China.* Atglen, Pennsylvania: Schiffer Publishing Ltd., 1998.

Parmer, Lynette. *Collecting Occupied Japan with Values.* Atglen, Pennsylvania: Schiffer Publishing Ltd., 1996.

INDEX